Top This!

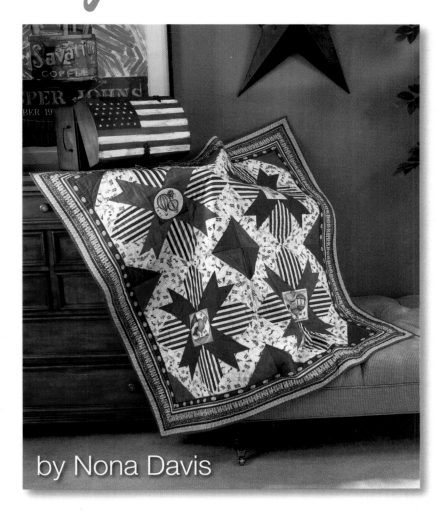

by Nona Davis

All American Crafts Publishing, Inc

Top This!

Text © 2008 Nona Davis

Artwork © 2008 All American Crafts Publishing, Inc.

All American Crafts Publishing, Inc.

7 Waterloo Road

Stanhope, NJ 07874

www.allamericancrafts.com

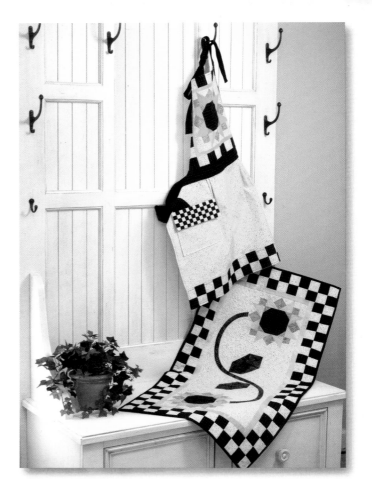

Publisher • **Jerry Cohen**

Chief Executive Officer • **Darren Cohen**

Editor • **Alison Newman**

Art Director • **Kelly Albertson**

Photography • **Van Zandbergen Photography**

Illustrations • **Kathleen Govaerts**

Technical Editing • **Donna Koenig**

Book Development Director • **Brett Cohen**

Vice President/Quilt Advertising

& Marketing • **Carol Newman**

Printed in USA

ISBN-13: 978-0-9789513-7-5
ISBN-10: 0-9789513-7-9
Library of Congress Control Number: 2008927326

Top This!

Dear Quilting Friends,

Quilters are busy people. Between family, careers and community service, few of us have the leisure time for quilting that we would like. My favorite projects are quick and practical, can be personalized for gift giving or made to accessorize a room or mark the changing seasons. Toppers fit the bill for all of these criteria. *Top This!* came about because I wanted to design small quilts suitable for different occasions and seasons. My challenge was to use different themes and styles of fabrics for each month of the year and to make projects that would be suitable for a variety of rooms in a home. Some of the projects have been made large enough to use as a tablecloth or throw. Most of us have made a table topper or runner for a dining room or kitchen table. Walk through your house and look at the myriad possibilities—coffee tables, dressers, mantles, even the back of a sofa or loveseat. Imagine a splash of color or design in these areas, emphasizing the decorating theme or an upcoming holiday.

The majority of the projects in this book were designed to be accomplished in a weekend. Feel free to experiment with color and style. For example, maybe you like the "shabby chic" look, and you aren't overly fond of green. The Double Lucky topper would look beautiful in "shabby chic" fabrics. Or choose an autumnal palette of batiks and make "Jack, the Runner" without a face. Make these projects your point of departure and enjoy the freedom to be creative. One of the benefits of small projects is that they don't require a large investment in materials or time. I challenge you to reach outside your personal "comfort zone" of color and fabric choices, and make something new and surprising.

I hope you will look at all the projects in this book and soon find yourself on the way to your local quilt shop, or contemplating the fabrics in your stash, inspired and eager to spend a few pleasurable hours making a quilted topper.

Finally I want to give a special thank you to Alison Newman for her many hours of work editing this manuscript. I appreciate that Alison was adamant that *Top This!* remain in my voice.

In Stitches,

Nona Davis

Table of

Contents

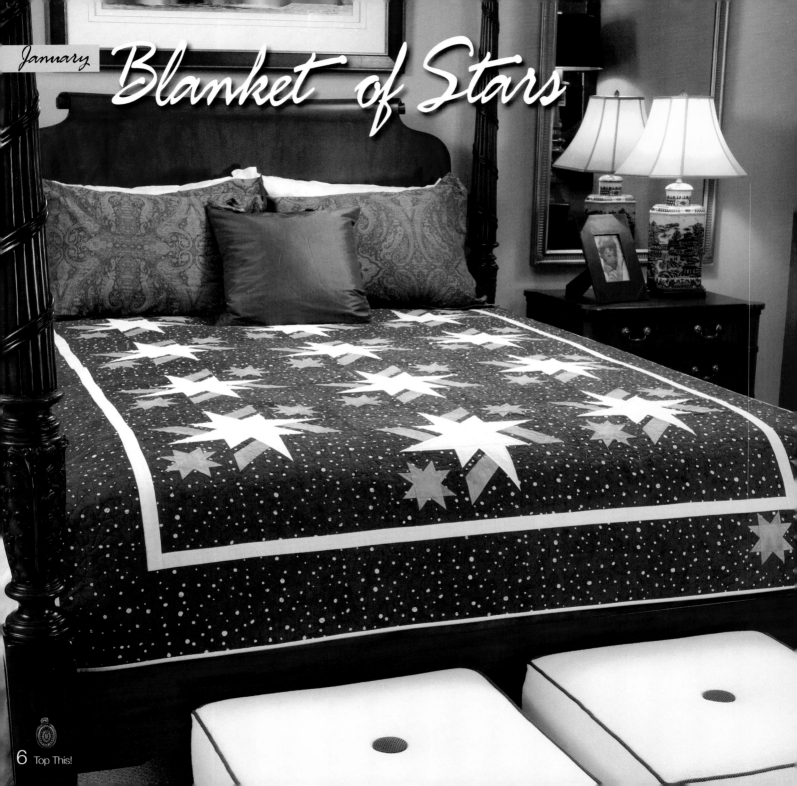

A new year means new beginnings. Start the year off with this star-studded quilt that reflects the crystalline clear nights of January. This project features some foundation or paper piecing, but at a beginner-friendly level.

Directions

1. Photocopy 48 foundation-pieced star point patterns onto foundation piecing paper. Use the same copier for all copies to limit distortion. Finished seam line is solid, outer seam allowance line is dotted. Trim each pattern so that there is an additional ¼" outside the dotted line. (*Tip:* You may choose to scan the pattern into your computer and then print it—this is often a more accurate way to copy foundation piecing patterns.)

2. Place the fabric pieces designated by numbers into separate piles.

3. Stack the rectangles for #5 right sides up. Place the rectangles so that the long sides are horizontal. Measure and mark ¼" down from upper right corner and ¼" up from lower left corner. Line up the two marks with your rotary ruler, then cut between the marks to yield 48 #5 pieces. Place all the #5 pieces in one pile. (See **Diagram 1**)

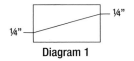

Diagram 1

Foundation Piecing Star Points

4. Beginning with piece 1 and ending with piece 5, foundation piece each star point in numerical order to create the 48 star points. (**Note:** If you have never foundation pieced or paper pieced before, make a couple extra copies of the pattern and then practice with scrap fabric.) When all foundation-pieced points are finished, turn paper right side up and trim on the dotted lines to the correct size. Very carefully remove the paper. Set star points aside.

Introduction to Foundation Piecing: Fabric pieces will be placed on the unprinted side of the paper foundation pattern. Place fabric piece 1 on its corresponding number with the wrong side of the fabric facing the paper and allowing the edges of the fabric to extend at least ¼" past the area 1 lines. If desired, pin in place. Place fabric piece 2 right sides together with fabric piece 1, ensuring that when the fabric piece 2 is flipped, it will cover its corresponding number 2 area on the paper foundation pattern and extend at least ¼" over the number 2 area. Turn the foundation piecing template over so the printed side is visible and sew on the line between area 1 and area 2 beginning and ending 3-4 stitches beyond the seamline. Trim seam to a scant ¼", flip fabric piece 2 over area 2 and finger press or press with a dry iron. Continue in the same manner, adding the appropriate fabric pieces in numerical order to complete the paper foundation pattern. Make sure you leave enough fabric to cover the ¼" seam allowance along pattern edges and trim.

Small sawtooth stars

5. Draw a diagonal line on the wrong side of the 1½" silver gray squares. Place a marked square on one corner of the 2½" navy batik squares. Sew on marked line and trim excess, leaving ¼" seam allowance. Press seam allowance toward the corner. Repeat on opposite end of the 2½" navy batik square. Repeat to make a total of one hundred and sixteen silver gray sawtooth star points. (See **Diagram 2**). In similar manner, make four *offset* lower sawtooth star points, this time using eight 1½" silver gray square and four 2½" x 3½" navy batik rectangles. (See **Diagram 2**).

make 116 make 4

Diagram 2

6. Trim four of the one hundred and sixteen 2½" silver gray sawtooth star points made in step five to 1½" x 2½", as illustrated in **Diagram 3**, to create four *offset* upper sawtooth star points.

make 4

Diagram 3

Finished size 62" x 82"

Materials
- 1¼ yards silver gray
- 1¾ yards white on white
- 5 yards navy batik with white dots
- Backing to fit 62" x 82"
- Batting to fit 62" x 82"
- 24 sheets of foundation paper with 2 star points on each page

Cutting
Note: Foundation or paper piecing pattern pieces are designated by bold numbers.

From silver gray:
30: 2½" squares
240: 1½" squares
48: 2½" x 5½" rectangles (for **#2** foundation pieced points)

From white on white:
12: 4½" squares (for star centers)
24: 3¼" x 6" rectangles (for **#5** foundation-pieced points)
24: 3½" squares, cut once diagonally (for **#4** foundation-pieced points)
8: 2¼" x WOF strips (for binding)
6: 1½" x WOF strips (for inner border)

From navy batik with white dots:
11: 6½" x WOF strips (set 7 aside for outer border); cut remaining 4 strips into
24: 6½" squares
216: 2½" squares
12: 2½" x 3½" rectangles
12: 1½" x 2½" rectangles
48: 5½" squares (for **#1** foundation-pieced points)
48: 1½" x 4½" rectangles (for **#3** foundation-pieced points)
3: 4½" x 16½" rectangles

7. Sew a silver gray sawtooth star point between two 2½" navy batik squares. Press seam allowance toward the navy batik squares. Repeat to make fifty-two units. (See **Diagram 4**)

make 52

Diagram 4

8. Noting orientation, sew a 2½" silver gray square between two 2½" silver gray sawtooth star points constructed in step 5, as shown in **Diagram 5**. Press seam allowance toward the silver gray square. Repeat to make thirty units.

make 30

Diagram 5

9. Following **Diagram 6,** sew the units together to form sawtooth star sections. You need a total of 24 small sawtooth stars for the main body of the quilt. Construct two more sawtooth stars for the upper left and lower right corners of the outer border. (Four outer border stars are offset and are constructed in the same manner, this time using the four *offset* upper sawtooth star points created in Step 6, the four *offset* lower sawtooth star points created in Step 5, and the four remaining sawtooth star/silver gray square units made in Step 8.)

Sawtooth Star

Off-Set Sawtooth Stars

Diagram 6

make 26 make 4

Assembly

10. Sew a 6½" navy batik square, a star point section and a sawtooth star section together as shown in **Diagram 7**. Make 24 star block outer segments.

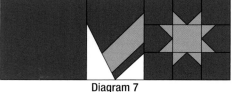

make 24

Diagram 7

11. Noting orientation, sew a 4½" white on white square between two star point sections. Repeat to create 12 star block inner segments. (See **Diagram 8**)

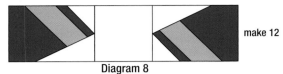

make 12

Diagram 8

12. Referring to the **Quilt Layout Diagram**, assemble blocks by sewing a star block inner segment between two star block outer segments. Make sure all star points point outward from center. Make twelve 16½" x 16½" blocks.

13. Sew blocks into three vertical columns of four blocks each. Sew a 4½" x 16½" navy batik strip to the bottom of each column. Press.

14. Flip the center column to stagger the stars slightly and then sew the vertical columns together. Refer to quilt diagram as needed. The quilt center should measure approximately 48½" x 68½"

15. *Inner Border.* Measure through the quilt center for width. Join the six white on white inner border strips together to make one long strip. Cut two pieces to width and sew to top and bottom of quilt center. In the same manner, measure length through center, cut two strips to length, and add to sides of quilt center.

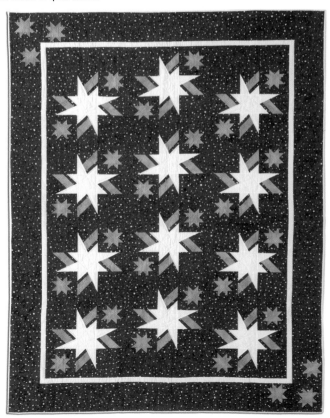

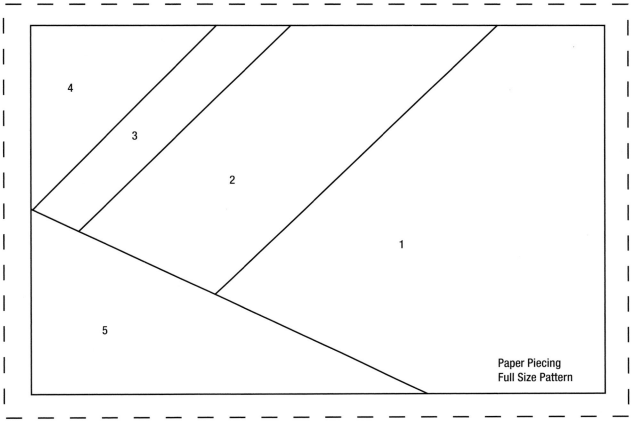

4

3

2

1

5

Paper Piecing
Full Size Pattern

16. *Outer Border.* Cut one outer border strip in half, then join one half short ends together to each of two outer border strips. Sew an offset sawtooth star block to one short end of both strips. Measure through the quilt top center for width. Cut the pieces made above to width and sew to the top and bottom of the quilt center. Sew two small sawtooth stars together, using one straight star and one offset star. Repeat to make two units. Sew two outer border strips together to make one long strip. Join the star units to one end of the strip, placing the straight star at the end of the strip. Measure through the quilt center for length, then cut the strip to that length. Sew to one side, making sure that stars are clustered together. Make the remaining outer border piece in the same manner. Refer to **Quilt Layout Diagram** for placement.

finishing

17. Layer pieced top, batting and backing and quilt as desired.
18. Add binding as desired using 2¼" white on white strips.

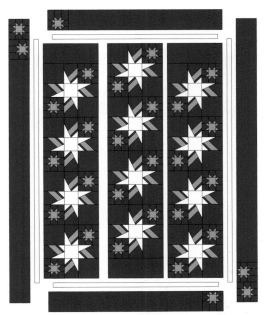

Quilt Layout Diagram

Star Crystals

A *slight* change of *color value* and a *bit* of *silver lamé* packs a lot of drama into this *smaller version* of the Blanket of Stars.

Directions

1. Photocopy 16 foundation-pieced star point patterns onto foundation piecing paper. Substitute colors as noted. Follow block directions for Blanket of Stars step 1-4.

2. Following Blanket of Star step 5-8, make 32 star points using the sixty four 1½" silver lamé squares and thirty two 2½" blue/gray swirl squares. Then make sawtooth stars using the star points, the 2½"silver lamé squares and the remaining 2½" light blue/gray swirl squares.

3. Using two 6½" light blue/gray swirl squares, four foundation pieced star points, two sawtooth stars and one 6½" mottled white and gray square, construct a 16½" x 16½" star block. Refer to image below for placement. Repeat to make a total of four blocks.

4. Sew the four completed blocks together in two rows of two blocks each.

Finishing

5. Layer and quilt as desired. Join binding strips end to end and bind as desired.

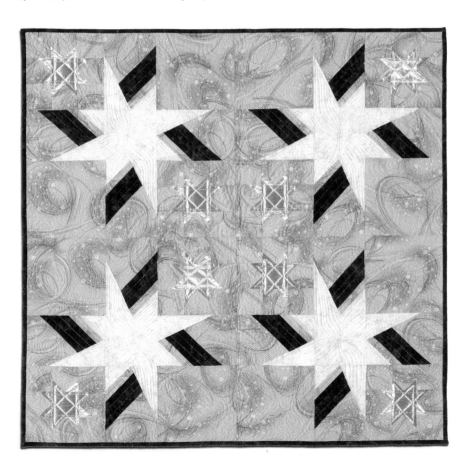

Finished size 32" x 32"

Materials
- 1¼ yards light blue gray swirl background (instead of navy dot batik)
- ½ yard mottled white and gray (instead of white on white)
- ⅝ yard navy marble (instead of silver gray in paper-pieced portion of the block, and for binding)
- ⅓ yard silver lamé (instead of silver gray in small sawtooth stars)
- ¼ yard lightweight fusible interfacing
- Foundation paper
- 38" x 38" backing
- 38" x 38" batting

Cutting
From the light blue gray swirl background:
8: 6½" squares
64: 2½" squares
16: 5½" squares (for **#1**)
16: 1½" x 4½" rectangles (for **#3**)

From the mottled white and gray:
4: 4½" squares
8: 3¼" x 6" rectangles (for **#5**)
8: 3¼" squares cut once diagonally (for **#4**)

From the navy marble:
16: 2½" x 5½" rectangles (for **#2**)
4: 2¼" x WOF strips (for binding)

From the silver lamé:
Tip: Lamé is more stable and easier to work with if you bond the lightweight fusible interfacing to the fabric before cutting. Lamé melts easily, so use a low temperature setting on your iron with a pressing cloth. Practice first with scraps.
8: 2½" squares
64: 1½" squares

Heart 2 Heart

This *romantic table runner* looks complicated, but is *easily constructed* of rectangles, half-square triangles, and Flying Geese units. *Clever color placement* creates the *tessellated heart pattern.*

Sweetheart

True Love

Be Mine

Valentine

Kiss Me

Directions

Large half-square triangle units

1. Draw a diagonal line on the wrong side of a white 3⅞" square. Place the square right sides together with a red square. Sew ¼" away from each side of the drawn line. Cut along line to yield two half-square triangle units. Press toward darker colored fabric. Repeat this step to make the following number of large half-square triangle units: 10 white/red, 10 pink floral/white, and 10 red/pink floral. You will need a total of nine of each color combination. (See **Diagram 1**)

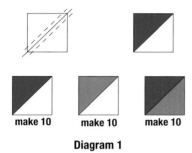

make 10 make 10 make 10

Diagram 1

Flying Geese units

2. Draw a diagonal line on the wrong side of two white 2" squares. Place a square right sides together on each end of a 2" x 3½" red rectangle as shown in **Diagram 2**. Sew on the drawn lines. Trim excess, leaving a ¼" seam allowance. Press open. Repeat this step to make the designated number of Flying Geese units outlined below.

make 3 of each

Diagram 2

Half-Flying Geese units

3. Draw a diagonal line on the wrong side of one white 2" square. Noting orientation, place the square right sides together on one end of a 2" x 3½" red rectangle. Stitch on the line, then trim, leaving a ¼" seam allowance. Press seam toward the darker fabric. Repeat this step to make the designated number of Half-Flying Geese units outlined below. (See **Diagram 3**)

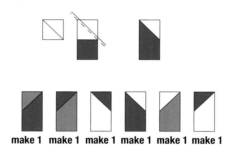

make 1 make 1 make 1 make 1 make 1 make 1

Diagram 3

Assembly

4. Following the **Layout Diagram** and using the large half-square triangle units, small half-square triangle units, flying geese units, half-flying geese units, and remaining pieces from cutting instructions, begin sewing the rows together starting with the 2" x 6½" rectangles at the top of the diagram. You may find it less confusing to lay out the entire project on a table or sew each row onto the previous one as they are pieced. (*Tip:* It might prove helpful to check off each row of the diagram with a pencil as you complete it.)

5. You may choose to hand or machine embroider appropriate sayings in some of the hearts.

Prairie Points

6. Using the 7¼" half-square triangles, fold each triangle in half right sides together, then stitch down the bias edge. Turn right side out and press. Position these triangles on top of each end of the runner, lining up raw edges and matching the colors of each triangle to the color at each end of the runner (the pointed end of the triangles are pointing toward the center of the runner). Baste to topper at raw edges using a ⅛" seam allowance. (See **Diagram 4**)

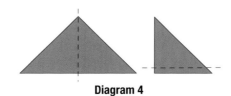

Diagram 4

Finished size 18" x 41"

Materials

Tip: Each fabric should be distinct from the others and non directional.

- ¾ yard red
- ¾ yard pink floral
- ¾ yard white with small red print
- 22" x 47" batting
- 22" x 47" backing

Cutting
From the red:
4: 2" x WOF strips, recut into nine 2" x 6½" rectangles, two 2" x 5" rectangles, and thirty-two 2" squares
14: 2" x 3½" rectangles
5: 3⅞" squares
1: 7¼" square, cut once diagonally

From the pink floral:
4: 2" x WOF strips, recut into ten 2" x 6½" rectangles, two 2" x 5" rectangles, and thirty 2" squares
13: 2" x 3½" rectangles
5: 3⅞" squares
1: 7¼" square, cut once diagonally

From the white with small red print:
4: 2" x WOF strips, recut into nine 2" x 6½" rectangles, two 2" x 5" rectangles and twenty-eight 2" squares
16: 2" x 3½" rectangles
5: 3⅞" squares
1: 7¼" square, cut once diagonally

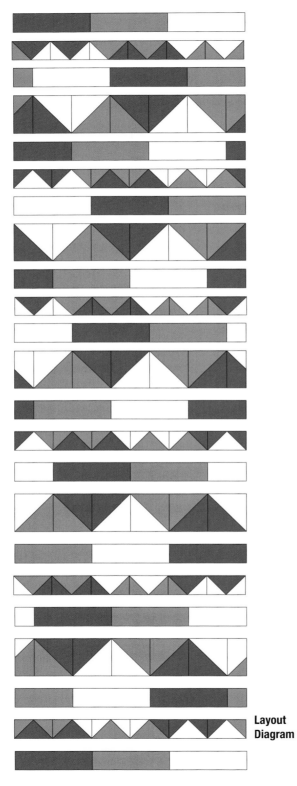

Layout Diagram

Finishing

7. Layer pieced front right sides together with backing. Place batting on top. Before stitching, make certain that prairie points are pointing inside, toward the center. (See **Diagram 5**) Stitch around the runner, leaving a 6" opening on one side for turning. Clip the corners and turn right side out. Press. Quilt as desired. Hand stitch the opening closed.

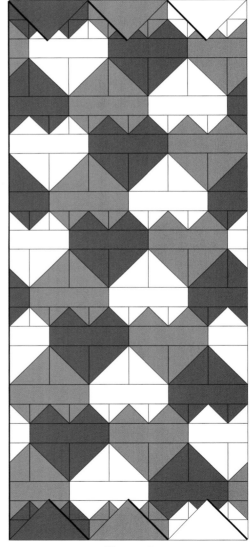

Diagram 5

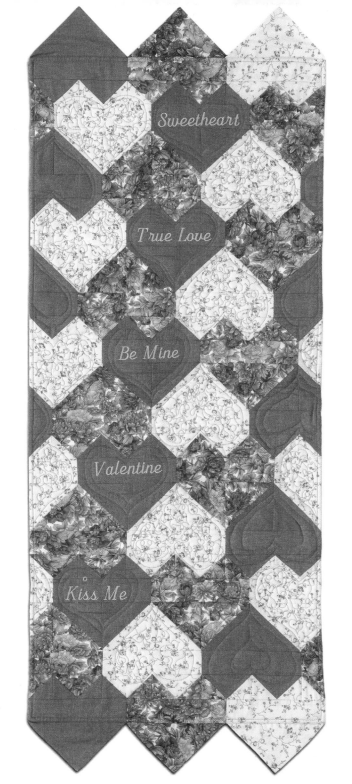

Dinner Conversation Placemats

Remember the *Conversation Hearts candy* that we used to get every February? Those *wordy little hearts* were the *inspiration for these romantic placemats.* You may choose to *embroider your own romantic sentiments* for each heart, or you may leave them blank.

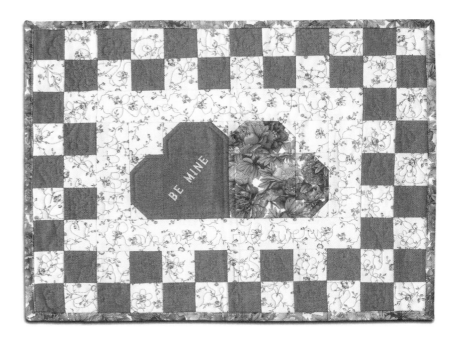

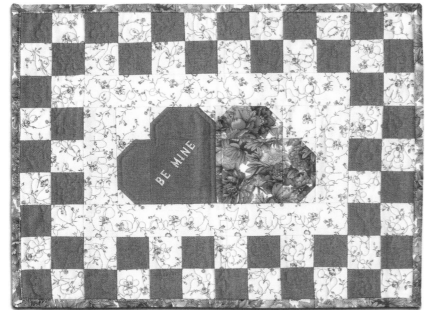

Directions

Four-patch units

1. With right sides together, sew the 2" wide red strips and 2" wide background strips together in pairs. Make a total of four pairs. Press seams toward the red fabric. (See **Diagram 1**)

make 4

Diagram 1

2. Cut the strip sets into sixty-eight 2" wide segments. (See **Diagram 2**) Set four segments aside. Pair up the remaining segments and sew together, using a scant ¼" seam allowance to make thirty-two four-patch units.

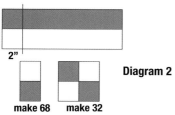

2"

make 68 **make 32**

Diagram 2

Heart Corner units

3. Draw a diagonal line on the wrong side of each 1¼" background square. Place a marked square on each end of a 2" x 3½" red rectangle. Stitch on the lines. Cut off corners, leaving ¼" seam allowance. Press toward corners to finish four red heart corner units. Repeat with pink rectangles to make four pink heart corner units. (See **Diagram 3**)

make 4 **make 4**

Diagram 3

4. Using heart corner units, 2" background squares, 3½" red squares, and 3½" pink squares, make the heart blocks as illustrated in **Diagram 4**. Make two red heart blocks and two pink heart blocks.

make 2 **make 2**

Diagram 4

5. Following **Diagram 5** and noting orientation, sew a red heart block to a pink heart block.

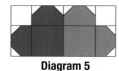

Diagram 5

6. Sew a 2" x 5" background strip to each end of the two heart blocks. Press seams toward the background strips. Sew a 2" x 12½" background strip to the top and bottom of the heart blocks. Press seam allowance toward the background strips to finish the 8" x 12½" placemat center.

Checkerboard borders.

7. For each placemat, make two strips containing four four-patch units each. The top border strip will have red in the upper left corner and the bottom border strip will have background in the upper left corner. (See **Diagram 6**) Sew the appropriate strips to the top and bottom of the placemat center. Press seams toward the background strips.

Diagram 6

8. Each checkerboard side strip is comprised of four four-patch units and one two-patch unit. The left side strip will have red in the upper left corner. The right side strip will have background in the upper left corner. Sew the appropriate side checkerboard units onto each side of the placemats, being careful to match the color repeat patterns and the seam allowances. (See **Diagram 7**)

Diagram 7

9. You may choose to machine or hand embroider the heart blocks with sentimental sayings.

finishing

10. Layer and quilt as desired.
11. Join two 2¼" pink binding strips together for each placemat and bind as desired.

Finished size 14" x 18"

Materials (for 2 placemats)
- ⅓ yard red
- ½ yard pink
- ½ yard of white or background
- ½ yard each batting and backing

Cutting (for 2 placemats)
From the red:
2: 3½" squares
4: 2" x 3½" rectangles
4: 2" x WOF strips

From the pink:
2: 3½" squares
4: 2" x 3½" rectangles
4: 2¼" strips; Join short ends of (2) strips (for binding)

From the white or background:
6: 2" x WOF strips; set 4 strips aside and recut remaining into four 2" x 12½" rectangles
4: 2" x 5" rectangles
4: 2" squares
16: 1¼" squares

Double Lucky

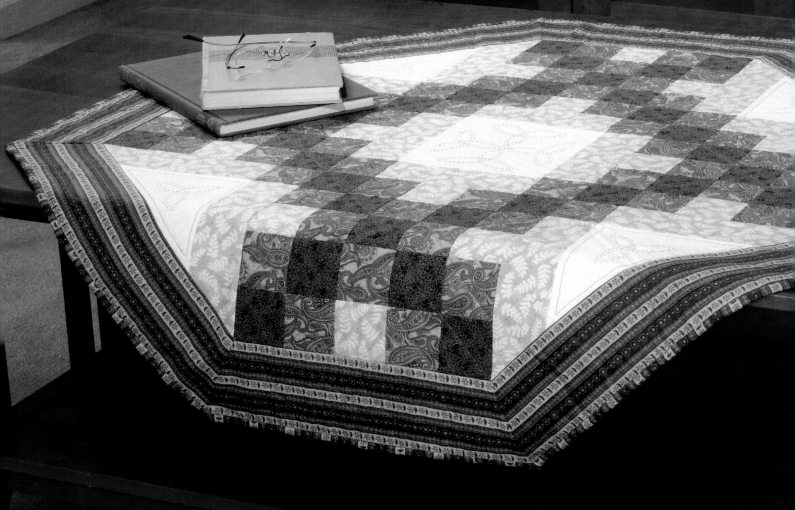

Combine the *luck of the Irish* with this *double Irish Chain* and a bit of
Celtic Knot quilting to make this *delightful octagonal topper.*

Directions

Strata Blocks

1. Sew the 2½" x 21" strips lengthwise together as indicated in **Diagram 1A**. Press seams toward the medium green fabric. Square up one end and cut eight 2½" wide strips for Strata A. Repeat with 2½" x 21" strips to create Stratas B and C, as outlined in **Diagrams 1B and 1C**. You will need eight 2½" wide Strata B units and four 2½" wide Strata C units.

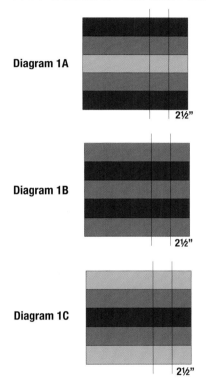

Diagram 1A

2½"

Diagram 1B

2½"

Diagram 1C

2½"

2. Using the cut strips of Stratas A, B, and C, sew the strata strips together in the following order: A, B, C, B, A, to create four matching blocks. Set the finished 10½" Strata Blocks aside. (See **Diagram 2**)

Diagram 2

Finished size 36" diameter octagon

Materials

- Fat quarter (18" x 22") white on white
- ⅓ yard dark green print
- ⅓ yard medium green print
- ½ yard light green print
- 1½ yards coordinating green border stripe (depending on pattern repeat and whether stripe runs vertical or horizontal to selvege)
- 42" piece of fabric for backing
- 42" piece of batting

Cutting

From the white on white:
1: 9¾" square, cut twice diagonally, yielding four Quarter Square Triangles
1: 6½" square

From the dark green:
3: 2½" x WOF strips, then cut strips in half to form 6 strips 2½" by (approx) 21"

From the medium green:
4: 2½" x WOF strips, then cut strips in half to form 8 strips 2½" by (approx) 21"; recut one 2½" x 21" strip into eight 2½" squares

From the light green:
5: 2½" x WOF strips, then cut 2 strips in half to form 4 strips 2½" x (approx) 21"; recut remaining 3 strips into eight 2½" x 8½" rectangles and four 2½" x 6½" rectangles

From the green border stripe:
6: 3½" x width OR length of fabric*
4: 2¼" x WOF strips (for binding)

**Open border strip fabric and refold with selvage to each side, lining stripes up exactly on top of themselves, then cut eight 3½" wide strips that are exactly alike (that is, the cuts will be through the same part of the border stripe, so that each border side will match); recut 2 strips to yield four 3½" x 20½" and remaining 4 strips to measure 3½" x 22½"*

Center Block

3. Sew a 2½" x 6½" light green rectangle to opposite sides of the 6½" white on white square. Press seams toward the light green fabric. (See **Diagram 3**)

Diagram 3

4. Sew a 2½" medium green square to each end of the two remaining 2½" x 6½" light green rectangles. Press seams toward the light green fabric.

5. Sew the units made in step 4 to the remaining two sides of the unit made in step 3 to finish the Center Block. (See **Diagram 3**). Press. Set aside.

Corner Triangle Units

6. Sew one of the light green 2½" x 8½" rectangles to a short side of each of the four white on white Quarter Square Triangles. Press seams carefully toward the light green fabric. (**Note:** Light green strip will be longer than needed. Do *not* cut at this time.)

7. Sew a 2½" medium green square to one end of four 2½" x 8½" light green rectangles. Aligning the 2½" medium green square with the light green strip added previously, sew this unit to the remaining short side of the white on white triangle. Repeat to make a total of four Corner Triangle Units. (See **Diagram 4**)

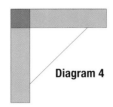

Diagram 4

Assemble the Topper

8. As shown in the **Quilt Layout Diagram**, sew a corner triangle unit to each side of two strata blocks assembled in step 2. Press seams toward the light green strips. Repeat to make two matching rows.

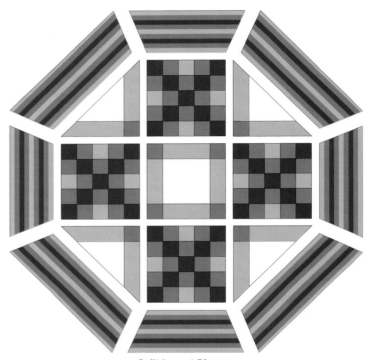

Quilt Layout Diagram

9. To make the center row, sew a strata block to each side of the center block made in step 5. Press seams toward the light green strips.

10. Assemble all three rows.

11. Press the topper. Place the topper on a rotary cutting mat and align the ruler with the edge of a corner triangle unit in a corner of the topper, extending the ruler through the corners of the strata blocks. Cut off the tails of the light green strips. Repeat for each corner. The topper should now be octagonal.

Mitered Borders

12. Find the center of a 3½" x 22½" green border stripe strip. Find the center of one white on white corner triangle unit on the topper. With right sides together and aligning centers, pin the border strips to each white on white corner triangle. Stitch borders to topper using a ¼" seam allowance, stopping and back-stitching ¼" from each corner.

13. Using a 3½" x 20½" green border strip, repeat step 12 for adjoining strata block sides. Press seams toward the border strip. Repeat for four strata blocks.

14. Using your favorite method, miter the eight corners of the topper.

finishing

15. Layer and quilt as desired.

Tip: Use your imagination when deciding how to embellish this table topper. If you have an embroidery machine, you may choose to embroider Celtic knots into the white on white spaces before finishing the topper. Another suggestion is to make Celtic knots from fusible bias tape. You could also draw and appliqué four-leaf clovers.

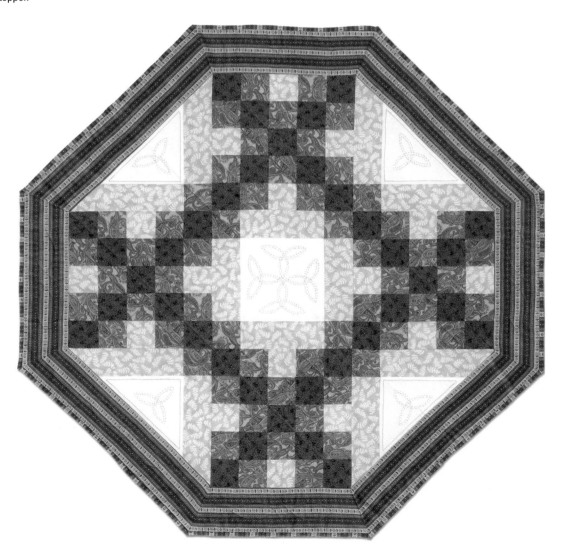

Double Lucky Placemats

These placemats are the perfect accompaniment to the Double Lucky table topper.

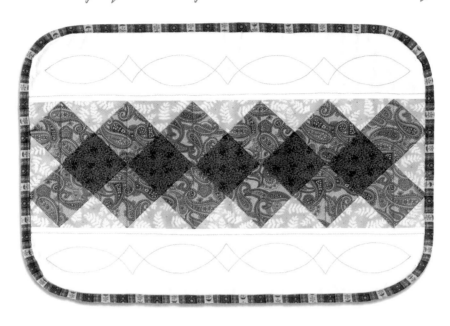

Directions

Strata A and B

1. Following **Diagram 1a**, make Strata A by sewing the strips lengthwise together in the indicated order. Press seams toward the medium green strip. Repeat to make a total of two strip sets. Square off the end and then cut thirty 2½" wide segments. Set aside.

2. Following **Diagram 1b**, sew strips lengthwise to create Strata B. Square off the end and cut twelve 2½" wide segments.

Center Strata Unit

3. For each placemat, sew five Strata A segments together, offsetting each subsequent segment. (See **Diagram 2**)

Diagram 1A

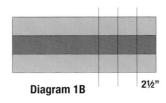

Diagram 1B

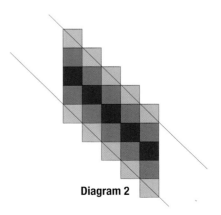

Diagram 2

4. Sew a 2½" light green square to a medium green square in a Strata B segment. (See **Diagram 3**) Repeat to make twelve end units.

5. Aligning a Medium Green square with a Dark Green square, sew the end unit made above to each side of the Strata A unit made in step 3 to complete the center strata unit. (See **Diagram 4**)

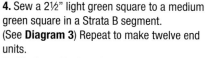
Diagram 3

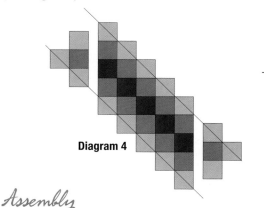
Diagram 4

Assembly

6. Press the center strata unit. Place the unit horizontally on the rotary cutting mat. Align the ruler so that edge is ¼" beyond the seam intersection of squares and through the diagonal of the light green squares. Cut with rotary cutter.

7. Rotate strata or cutting mat and cut all four sides in same manner. The resulting unit will have the medium green and dark green squares on point, surrounded by light green triangles. (See **Diagram 5**)

8. Being careful not to stretch the bias edges, sew the 3½" x 17½" white on white rectangles onto the long sides of the strata unit. (See **Diagram 5**)

Diagram 5

Top

Side

Fold

Placemat Pattern
Increase 200% for Full Size
Final size should be 6" x 9¾"

Trace the rounded corner
from register mark to register
mark. Use this to round the
corners of the placemat.

Bottom

Finishing

9. Layer each placemat top with backing and batting. If desired, trace the curve pattern above onto paper and place in each corner of the placemat. Cut the curve.

10. Layer the placemat top, batting and backing and quilt as desired.

11. Bind as desired using the 2¼" wide dark green strips.

Tip: This pattern works well using a border print in place of the white on white and coordinating colors in the strata. Try this with holiday fabrics.

Finished size 12" x 17"

Materials (for 6 placemats)
- ½ yard medium green
- ⅔ yard white on white
- ⅝ yard light green
- ¾ yard dark green
- 1 yd backing
- 1 yd batting (45" wide)

Cutting
From the medium green:
5: 2½" x WOF strips

From the white on white:
12: 3½" x 17½" rectangles

From the light green:
12: 2½" squares
6: 2½" x WOF strips

From the dark green:
2: 2½" x WOF strips
9: 2¼" x WOF strips
(for binding)

Nested Pinwheels

*Welcome the return of
sunshine and delicate flowers
with this spring-inspired table topper.*

Directions

Note: Piecing this topper is not technically difficult; however, accuracy in cutting and sewing is essential to getting your pinwheels to nest.

Block Assembly

1. Draw a diagonal line on the wrong side of all 2½" white on white squares and all 2½" yellow print squares. Place a marked yellow print square right sides together on opposite corners of a 4⅞" white on white square, as shown in **Diagram 1**. Stitch on the drawn lines and trim seam allowance to ¼". Press seams toward the white on white fabric. Repeat to complete thirty-two 4⅞" white on white square units.

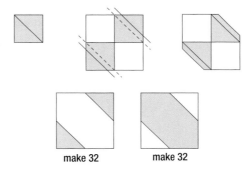

make 32 make 32

Diagram 1

2. Repeat step one using marked 2½" white on white squares and 4⅞" yellow print squares. Press seams toward the yellow fabric. Repeat to complete thirty-two 4⅞" yellow print square units.
3. Following **Diagram 2**, draw a diagonal line on the wrong side of all of the 4⅞" white on white and yellow print square units made above.

Diagram 2

Finished size 40" x 40"

Materials
- Fat quarter deep coral batik (for tulip flowers)
- Fat quarter medium green batik (for tulip stems)
- ¼ yard marbled apple green
- ⅞ yard pink floral print
- 1 yard white on white
- 1 yard yellow print
- Fusible web
- 46" x 46" piece of batting
- 46" x 46" piece of backing

Cutting
From the marbled apple green:
4: 1½" x WOF strips (for inner border)

From the pink floral print:
4: 3½" x WOF strips (for outer border)
5: 2¼" x WOF strips (for binding)

From the white on white:
32: 4⅞" squares
64: 2½" squares

From the yellow print:
32: 4⅞" squares
64: 2½" squares

4. With right sides together and corners nesting, place the 4⅞" white on white square units together with the 4⅞" yellow print square units. Sew, using a scant ¼" seam allowance, on either side of the drawn line. Cut apart on the line. Press seams toward the primarily yellow side. Repeat to make a total of 64 blocks. (See **Diagram 3**)

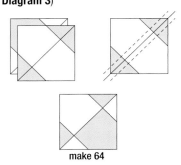

make 64

Diagram 3

Assembly

5. Sew eight rows of eight blocks together for body of table topper. Position the blocks in such a manner that the intersection creates a small pinwheel. (See **Layout Diagram**)

Layout Diagram

6. *Inner border.* Measure through the center of the pieced topper for border width (should measure 32½"). Cut two 1½" wide marbled apple green strips to that width. Sew a strip to each side of the topper. Press seams toward the inner border strips. Measure through the center of the pieced topper for border length. Cut the remaining two marbled apple green strips to that length. Attach to the remaining sides of the topper. Press seams toward the inner border strips.

7. *Outer border.* Attach the outer border in the same manner as the inner border. Press seams toward the inner border.

8. Using the tulip pattern found on page 27, trace tulip petals onto paper side of the fusible web. Each tulip is formed from one of each of three petal shapes. Trace 12 each of the petal shapes. Fuse onto deep coral batik. Cut out neatly. Tulip stems, flower bases and leaves are formed from slightly shifting the position of the stem and leaf shapes provided. Trace onto fusible web 12 stems and two or three leaf shapes and flower bases for each grouping of tulips. Arrange the appliqué shapes on the corners of the topper with the tulips toward the center. Fuse in place. Use matching thread to appliqué around the raw edges of the shapes.

Finishing

9. Layer and quilt as desired.
10. Join the pink floral binding strips into one long strip and bind as desired.

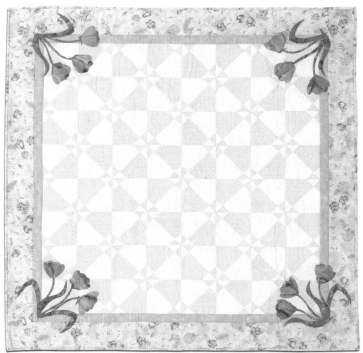

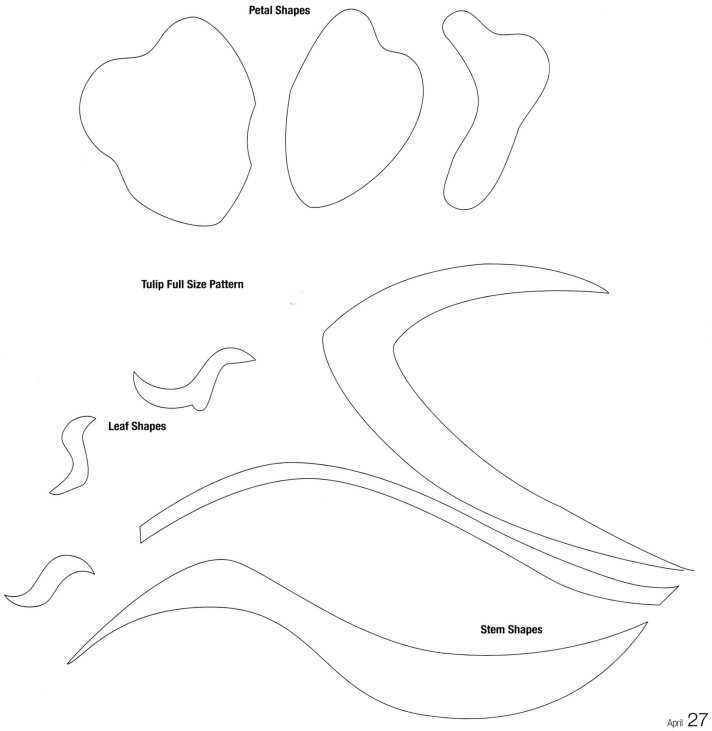

Petal Shapes

Tulip Full Size Pattern

Leaf Shapes

Stem Shapes

Midnight Garden

The body of this runner is made the same way as the Nested Pinwheel.
The dramatic difference in appearance is due to the change in fabric colors.

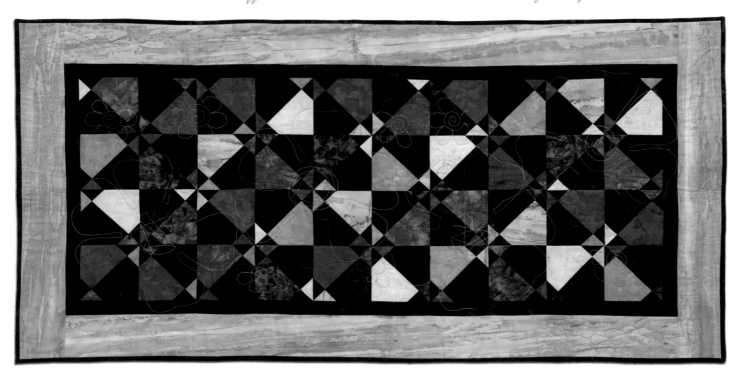

Directions

Note: Directions for constructing the Midnight Garden runner are exactly the same as for the Nested Pinwheels, except this quilt uses a variety of different colors, each paired with black batik.

1. Draw a diagonal line on the wrong side of all 2½" black batik squares and all 2½" different color batik squares. Place a marked black batik square right sides together on opposite corners of a 4⅞" different color batik square, as shown in **Diagram 1**. Stitch on the drawn lines and trim seam allowance to ¼". Press seams toward the different color batik fabric. Repeat to complete twenty 4⅞" different color square units.

make 20

make 20

Diagram 1

2. Repeat step 1, this time attaching forty 2½" different color batik squares to twenty 4⅞" black batik squares. Place different colors on each opposing corner of the black batik squares. Press seams toward the black batik squares to complete twenty 4⅞" black batik square units.

3. Following **Diagram 2**, draw a diagonal line on the wrong side of all of the 4⅞" different color batik and black batik square units made above.

Diagram 2

4. With right sides together and corners nesting, place the 4⅞" black batik square units together with the 4⅞" different color batik square units. Sew, using a scant ¼" seam allowance, on either side of the drawn line. Cut apart on the line. Repeat to make a total of 40 blocks. (See **Diagram 3**)

make 40

Diagram 3

5. Following Runner Image, sew four rows of ten blocks each for the body of the runner. Position the blocks in such a way that intersection creates a small pinwheel. Strive for a very scrappy look, distributing the colors throughout the runner.

6. Measure through the center of the runner for the width (should measure 40½"). Cut two 1½" wide black batik strips to that width and then sew to the top and bottom of the runner. Measure through the center of the runner for length (should measure 18½"). Cut one of the remaining 1½" wide black batik strips into two strips of that length and then sew to the top and bottom of the runner.

7. Join three 4½" x WOF multicolor batik outer border strips short ends together into one long strip. Cut this strip in half. Measure through the center of the runner for the width. Cut two strips to that length, then sew to the top and bottom of the runner. Measure through the center of the runner for length. Cut remaining two 4½" multicolor batik strips to length and sew to sides of runner.

finishing

8. Layer and quilt as desired.

9. Join the 2¼" black batik strips into one long strip, and bind as desired.

Finished size 26" x 50"

Materials
- ¼ yard each of 4 different color batiks
- ⅔ yard multicolor batik
- 1 yard black batik
- 32" x 56" backing
- 32" x 56" batting

Cutting
From each of the four different color batiks:
5: 4⅞" squares (for a total of twenty 4⅞" squares)
10: 2½" squares (for a total of forty 2½" squares)

From the multicolor batik:
5: 4½" x WOF strips (for outer border)

From the black batik:
20: 4⅞" squares
40: 2½" squares
3: 1½" x WOF strips (for inner border)
4: 2¼" x WOF strips (for binding)

May Bloomin' Baskets

Delicate china teapots and baskets of fragrant roses are natural companions for this decidedly feminine topper.

Directions

Basket Units

1. Place a 6⅞" cream swirl triangle right sides together with a 6⅞" gold basket weave triangle. Sew together down bias edge using ¼" seam allowance. Open, then press seams toward the gold basket weave fabric. Repeat to make four half square triangles. (See **Diagram 1**)

make 4

Diagram 1

2. Following **Diagram 2** and noting orientation, sew a 2⅞" gold basket weave triangle to one end of each 2½" x 4½" cream swirl rectangle. Make a total of eight side units, four in each orientation.

Diagram 2

make 4 make 4

3. Sew a side unit made in step 2 to the gold basket weave sides of each half square triangle made in step 1. Repeat to make four units. (See **Diagram 3**)

Diagram 3

make 4

4. Place a 4⅞" cream swirl triangle right sides together with the gold basket weave triangles of the units added in step 3. Sew along the bias edge using a ¼" seam allowance. Press seams toward the cream swirl triangle. (See **Diagram 4**)

Diagram 4

5. Noting orientation, sew a 2½" x 8½" cream swirl rectangle to the side of each basket block unit. Sew a 2½" x 10½" cream swirl rectangle to the remaining side to complete four 10½" x 10½" basket blocks. (See **Diagram 5**)

Diagram 5

Assembly

6. Sew the basket blocks together in two rows of two blocks each with the cream swirl triangles added in step 4 positioned in the outer corners.

7. Fold the 1¼" wide gold basket weave bias strips lengthwise in half with wrong sides together. Gently press the fold. Unfold and with wrong sides together fold each raw edge into the fold mark. Press.

8. Find the center of the bias strip, and pin to the outside top edge of one of the basket blocks. Form a nice smooth arch, staying ¼" within the seam allowances of the block. Pin along the arch of the basket handle, leaving a ¼" tail below the top edge of the basket. Trim excess fabric. Fold under the ¼" tail and pin to the remaining outside top edge of the basket. Stitch in place using a tiny zigzag stitch with matching thread or monofilament. Repeat for all four baskets.

9. Place the fused bouquets onto the baskets so they overlap the basket front by about one-third. The remaining two-thirds of the bouquet should cover the background between the basket top and handle—it is fine to overlap the basket handle somewhat. (**Note:** It is most visually pleasing if the bouquets are not all identical.) Fuse in place.

10. Sew a 2½" x WOF marbled dark red strip to each side of the pieced top, stopping ¼" from each corner. Using method of choice, miter the corners.

Finished size 34" x 34"

Materials
- ⅜ yard gold basket weave
- ½ yard cream swirl
- 1 yard marbled dark red
- 1⅛ yard large floral bouquet
- Water-soluble thread
- Fusible web
- 40" x 40" piece of backing
- 40" x 40" piece of batting

Cutting

From the gold basket weave:
2: 6⅞" squares, cut once diagonally
4: 2⅞" squares, cut once diagonally
4: 1¼" bias strips at least 13½" long

From the cream swirl:
2: 6⅞" squares, cut once diagonally
2: 4⅞" squares, cut once diagonally
4: 2½" x 10½" rectangles
4: 2½" x 8½" rectangles
8: 2½" x 4½" rectangles

From the marbled dark red:
4: 2½" x WOF strips (for inner border)
1: 20" square for making bias binding, cut once diagonally; cut 2¼" strips, aligning ruler along bias edge; join strips together, interspersing long strips and short strips, to make one long strip that measures about 170" long (for scalloped outer border)

From the large floral bouquet:
4: 7½" x 33½" strips (for scalloped outer border)
From remainder of fabric, fussy cut four bouquet motifs approximately 6½" in diameter, then cut four 7" squares of fusible web; fuse onto wrong side of floral bouquets and cut out neatly

11. Trace the scallop pattern provided on page 33 onto the template plastic. Cut out neatly. With right sides together, fold the 7½" wide floral border strip in half, matching up the short ends. Place the folded strip horizontally on your work surface with the fold to the right. Using your rotary ruler as a straight edge, measure and mark a line ¼" from the top edge along the length of the folded piece. (See **Diagram 6**)

¼"

fold

Diagram 6

12. Following **Diagram 7**, place the scallop template on the folded border strip, aligning the center part of the scallop on the fold and the "point" side of the scallop along the drawn line. Trace the edge of the template, including the ⅛" 'flat spot'. (This ⅛" will allow turning space for the scallop points.) Continue tracing the template along the remainder of the fabric strip. (See **Diagram 8**)

Diagram 7

Diagram 8

13. With water soluble thread in both the top of the machine and in the bobbin and leaving the border strip folded, use a basting stitch to sew along marked scalloped edge from open end to fold. Trim seam allowance, leaving a scant ¼". Turn right side out and push out the points with a knitting needle or bamboo skewer. (See **Diagram 9**) Set the iron on high heat and use steam to press along the scalloped edge of the border piece. (**Note:** Do *not* press the fold.) Spritz with water if necessary. The steam and water will dissolve the water-soluble thread; when it does, gently unfold the border piece. The scalloped edge will have a crisply turned-under edge.

Diagram 9

14. To scallop the bottom edge of the border piece, draw a line on wrong side of the border fabric the length of the strip 1" from the bottom edge - opposite the completed scallop. Line up the top point of the template along the drawn line. Starting at the center of the strip and working toward the outside edges, trace the template and then cut out neatly. Repeat for all four outer border strips. (See **Diagram 10**)

1"

Diagram 10

15. Pin the outer border strips on top of the marbled dark red fabric, so that the rounded part of the center scallop (where the fold was) lines up with the topper center seam, as seen in **Diagram 11**. (When the outer border piece is laid on the inner border strip, a point should be within 1/8" from each corner.) There are five full scallops on each side centered on the inner border. Beginning with two adjacent sides and allowing excess fabric to overlap on the corners, align the scallops in each outer border piece with the topper center. Sew each outer border piece to the topper using matching thread or monofilament with a tiny zigzag stitch, beginning and ending each seam about 7" from each corner. Miter the corner using method of choice, then stitch down the little keyhole where the outer border meets on each side. Repeat with subsequent adjacent sides.

Fold Line

Diagram 11

finishing

16. Layer the topper with backing and batting. When quilting, outline the bouquets in the baskets. Be creative when quilting the details in the flowers and leaves.

17. Sew a basting stitch just inside each outer border scallop. Using scissors or rotary cutter, trim batting and backing even with the topper scallops. Bind the quilt as desired using marbled dark red bias strips.

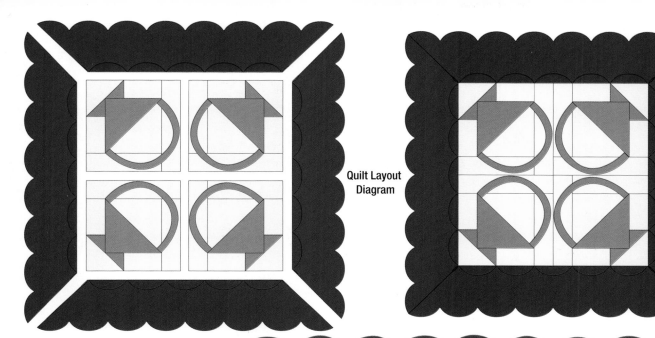

Quilt Layout
Diagram

Flat Spot

Scallop Full Size Pattern

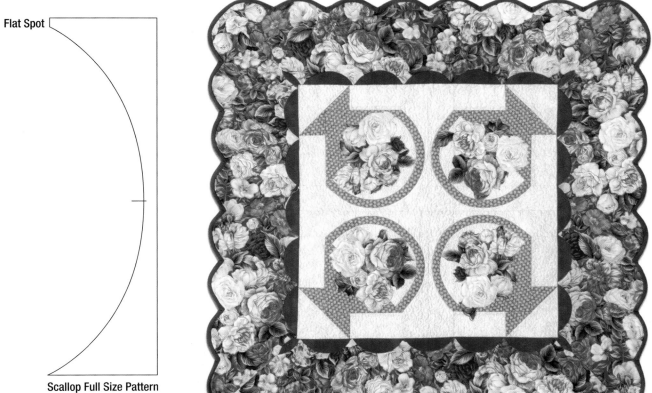

Bloomin' Basket Tea Cozy

This pretty tea cozy is the perfect and practical accompaniment for any tea party!

Directions

1. Following **Diagram 2,** draw a diagonal line on the wrong side of the 2¾" gold basket weave squares. Place a square right sides together on one corner of a 4½" cream swirl square. Sew on the marked line. Trim excess, then press seam toward the gold basket weave triangle. Repeat to make two units.

Diagram 2

2. Cut each of the units made in step 1 diagonally in half through the gold basket weave corner to yield four triangle units. (See **Diagram 3**)

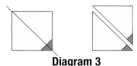

Diagram 3

3. Sew the triangle units made in step 2 to each side of the gold basket weave basket triangles cut above. (See **Diagram 4**)

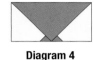

Diagram 4

4. Sew a 5" x 8" cream swirl rectangle to the long side of the gold basket weave basket triangle.
5. Follow steps 7 and 8 of the Bloomin' Baskets project to make basket handles using the 1" wide gold basket weave bias strips. Repeat for both baskets.
6. Arrange the fused bouquet motifs as desired on the baskets. Fuse into place.
7. Sew a 2¾" x 8½" large floral strip to each side of each basket block. Stitch a 2¼" x 12½" large floral strip to the top of each block.

Finishing

8. Layer each of the basket blocks with batting and muslin. Quilt as desired, making sure to outline the fused bouquets.
9. Make a template using the cozy pattern on the right. Trim each block to size.
10. Cut two pieces from the lining fabric to the same size as the basket blocks. Layer the cozy as follows: basket block right side down, lining fabric right side up (wrong side facing muslin of first basket block), remaining lining fabric right sides together with the first lining fabric, remaining basket block right side up on top. Align all the edges.
11. Fold one of the binding strips lengthwise in half with wrong sides together. Press. Starting at one side edge of the layered basket blocks and linings and

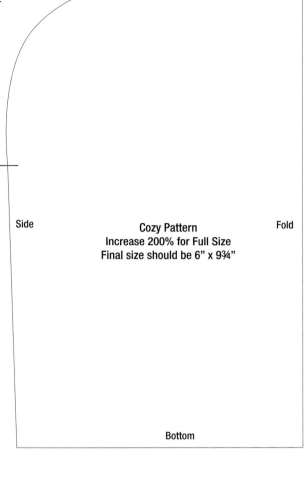

Top

Side

Fold

Cozy Pattern
Increase 200% for Full Size
Final size should be 6" x 9¾"

Bottom

leaving about 1" tail at each end, pin the binding up one side, across the curves and top, and down the remaining side. **(Note:** If a loop is desired at the top, make the loop using a length of binding strip about 7" long, press together with raw edges enclosed, then stitch close to edge. To adhere to cozy, slide the raw edges between the binding and tea cozy top.) Using an even feed foot or walking foot with a ¼" seam allowance, stitch through all the layers with the binding on the top. Fold the binding over the raw edges of the tea cozy, and hand stitch to other side using a blind stitch with matching thread. Bind the bottom of the tea cozy with the remaining binding strip.

Finished size approximately
12" x 9¾"

Materials
• Fat quarter cream swirl
• Fat quarter gold basket weave
• ¼ yard large floral bouquet
• ⅛ yard marbled dark red
• ½ yard muslin
• ½ yard lining
• Fusible web
• Batting
• Even feed or walking foot

Cutting
From the cream swirl:
2: 5" x 8" rectangles
2: 4½" squares

From the gold basket weave:
2: 4" x 8" rectangles; draw a 45° line to run from upper left corner of each rectangle to center and cut; repeat for right side to create basket triangles (See **Diagram 1**)

Diagram 1

2: 2¾" squares
2: 1" x approx. 12" bias strips (for basket handles)

From the large floral bouquet:
4: 2¾" x 8½" rectangles
2: 2¼" x 12½" rectangles
Save remaining fabric for bouquet motifs

From the fusible web:
2: 5" squares; find bouquet motifs on remaining large floral bouquet fabric that measure approximately 5", then apply fusible web square to wrong side of fabric and cut out neatly

From the marbled dark red:
2: 2¼" x WOF strips (for binding)

Bears in These Woods

*Summer is time to **commune with nature**. Whether camping at the lake or enjoying your backyard, get that **woodsy feel** by setting the table with these **hungry bears!***

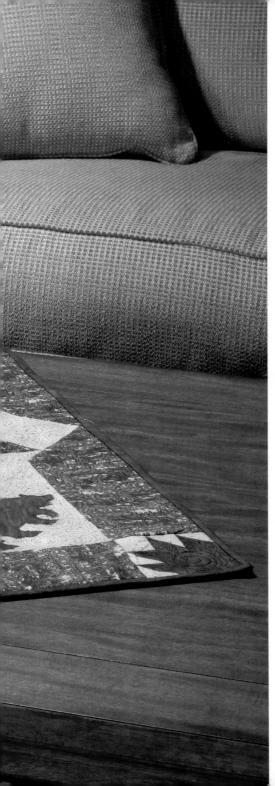

Finished size 28" x 28"

Materials
- ⅔ yard tan background
- ¾ yard dark brown
- ¾ yard tree print
- Fusible web
- 34" x 34" piece of backing
- 34" x 34" piece of batting

Cutting
From the tan background:
4: 1½" squares
8: 1⅞" squares
4: 3½" squares
8: 3⅞" squares
4: 2" x 9½" rectangles
2: 8¾" squares, cut once
 diagonally to yield two
 half-square triangles

From the dark brown:
8: 1⅞" squares
8: 2⅜" squares
4: 2½" squares
4: 3½" squares
3: 2¼" x WOF strips (for binding)
Reserve remainder for bear
appliqués

From the tree print:
4: 2" x 5" rectangles
5: 2" squares
4: 2" x 6½" rectangle
8: 2⅜" squares
8: 3½" x 11½" rectangles
 (for outer border)
8: 3⅞" squares

Directions

Half-square triangles

1. Draw a diagonal line on the wrong side of eight 3⅞" tan background squares. Following **Diagram 1**, place each 3⅞" tan background square right sides together with eight 3⅞" tree print squares. Stitch ¼" away from each side of the drawn line, then cut apart to yield sixteen 3½" half-square triangle units. Press seams toward tree print fabric.

make 16

Diagram 1

2. Follow the same procedure to pair the eight 2⅜" dark brown squares and eight 2⅜" tree print squares to yield sixteen 2" half-square triangle units. In the same manner, pair the eight 1⅞" dark brown squares and eight 1⅞" tan background squares to yield sixteen 1½" half-square triangle units. Press all seams toward darker fabric. Place half-square triangles in piles according to size.

3. Referring to **Diagram 2** and noting orientation, sew the half-square triangles made above into pairs. Make four double half-square triangle units of each orientation.

make 4 make 4

make 4 make 4

make 4 make 4

Diagram 2

4. Sew a 1½" tan background square to the left end of a 1½" dark brown/tan background double half-square triangle unit, using **Diagram 3** as a guide. Repeat to make a total of four units.

Diagram 3

make 4

5. Repeat step 4, using the 2" dark brown/tree print double half-square triangles and the 2" tree print squares. Repeat the same procedure using the 3½" tan/tree print double half-square triangle units and 3½" tan background squares. (See **Diagram 4**)

make 4

Diagram 4

make 4

Bear Paw Units

6. Sew the remaining four 2" dark brown/tree print double half-square triangle units to the four 3½" dark brown squares, aligning the dark brown fabric as shown. (See **Diagram 5**)

Diagram 5

7. Sew the pieces made in step 5 to the top edge of the pieces made in the previous step, aligning the dark brown fabric as shown in **Diagram 6**.

Diagram 6

8. Sew a 2" x 5" tree print rectangle to one "toe" side of each of the Bear Paws assembled in step 7. Press seams toward the tree print rectangle.

9. Sew a 2" x 6½" tree print rectangle across the remaining "toe" side of the Bear Paws, perpendicular to the rectangle added in step 8. Press seams toward the rectangle. Complete all four Bear Paw units in the same manner. (See **Diagram 7**)

Diagram 7

Inner Topper Assembly

10. Using the tree print/tan background double half-square triangle units made in step 3 and noting orientation, sew the units to the side of the Bear Paw units completed in step 9. (See **Diagram 8**) Sew the 3½" unit made in Step 5 to the top of the Bear Paw unit. Complete all four 9½" x 9½" Bear Paw Blocks in the same manner.

Diagram 8

11. Sew a completed Bear Paw Block to each long side of a 2" x 9½" tan background strip as shown in **Quilt Layout Diagram**. Repeat to make two sections. Press seam allowance toward the tan background fabric.

Quilt Layout Diagram

12. Sew the 2" tree print square short ends together between two 2" x 9½" tan background strips. Press seam toward the tan background fabric. Following the layout diagram, stitch this unit between the sections completed in step 11. Press seam allowance toward the tan background strip. Set aside.

Border Assembly

13. Using the 1½" double half-square triangle units, 1½" tan background square/double half-square triangle units, and 2½" dark brown squares, follow steps 6 and 7 to construct four small Bear Paw blocks.

14. Sew a 3½" x 11¼" tree print strip to one "toe" side of the small Bear Paw blocks made above. Sew a 3½" x 11¼" strip to one short side of the tan background half square triangles. Sew the small Bear Paw/strip unit to the triangle/strip unit. Repeat to make a total of four units. (See **Diagram 9**)

15. Line up the rotary ruler with the cut edge of the triangle. Trim tree print strips even with the cut edge of tan background triangle.

16. Sew the triangular units made above to each side of the Inner Topper. Press seams.

17. Trace the small bear shape (pattern below) four times onto fusible web. Following manufacturer's instructions, fuse onto the wrong side of the dark brown fabric. Cut out neatly. Remove the paper backing and fuse onto the tan background triangles. Machine stitch around the raw edges of the appliques.

Finishing

18. Layer and quilt as desired.
19. Bind as desired using the dark brown binding strips.

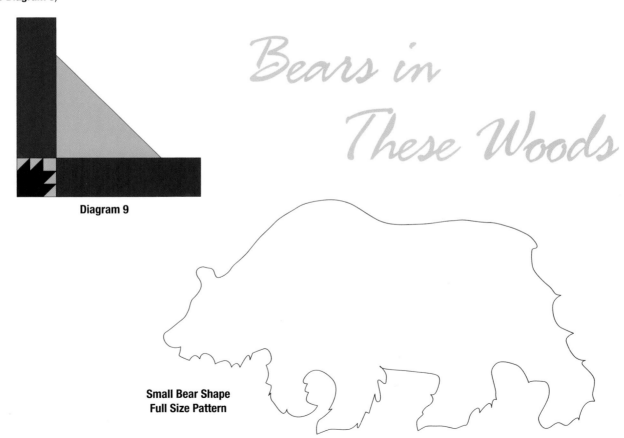

Diagram 9

Bears in These Woods

**Small Bear Shape
Full Size Pattern**

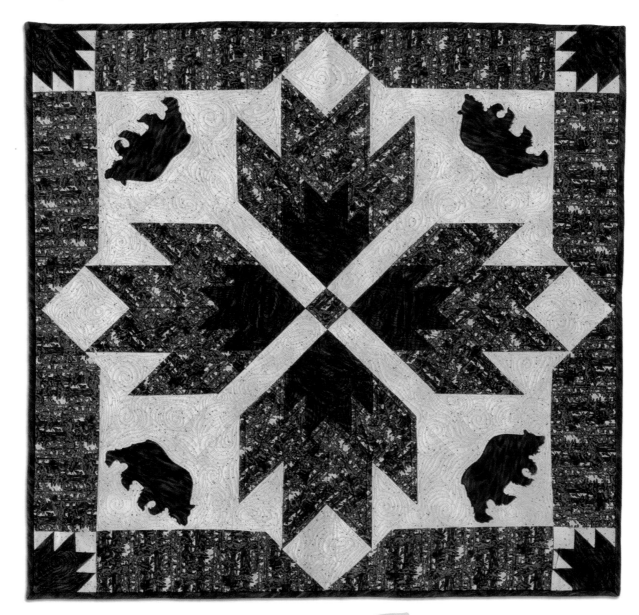

Bears in These Woods Placemats

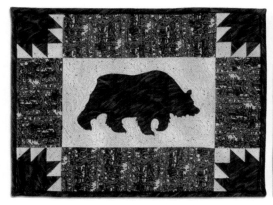 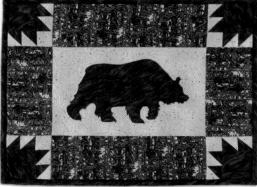

Finished size 12" x 16"

Materials (for four placemats)
- ½ yard tan background
- ½ yard tree print
- ⅞ yard dark brown
- Fusible web
- 1 yard backing
- 1 yard batting

Cutting
From the tan background:
4: 6½" x 10½" rectangles
32: 1⅞" squares
16: 1½" squares

From the tree print:
8: 3½" x 10½" rectangles
8: 3½" x 6½" rectangles

From the dark brown:
16: 2½" squares
32: 1⅞" squares
7: 2¼" x WOF strips (for binding)
Reserve remainder for bear
 appliqués

Directions

1. Following the directions for making the small Bear Paw blocks for the Bears in These Woods table topper, make four small Bear Paw blocks for each placemat. Set aside.

2. Sew a 3½" x 10½" tree print strip to each long side of the 6½" x 10½" tan background rectangle. Press seam allowance toward tree print fabric.

3. Referring to the placemat image for orientation, sew the small Bear Paw blocks made in step 1 to each end of a 3½" x 6½" tree print rectangle. Press seam allowance toward the tree print fabric.

4. Sew Bear Paw/tree print unit made in step 3 to each end of the unit made in step 2. Press.

5. Trace a large bear shape (pattern below) onto fusible web for each placemat. Following manufacturer's directions, fuse the traced shape onto the wrong side of the dark brown fabric. Cut out neatly. Fuse onto the center of tan background placemat center. Machine appliqué around raw edges.

Finishing

6. Sandwich and quilt the placemats as desired.
7. Join two dark brown binding strips for each placemat, then bind as desired.

**Large Bear Shape
Full Size Pattern**

Flyin' High

Americana colors transcend all the seasons. This throw sized topper *looks good in a bedroom,* on the *picnic table* or across the back of a *porch swing.*

Directions

Half-square triangles

1. Draw a diagonal line on the wrong side of the eight 5⅞" light blue background squares. Place four squares right sides together with four 5⅞" red tonal squares. Stitch a scant ¼" away from each side of the lines. Cut apart on the lines. Press open, with seam allowance toward the darker fabric. Repeat, using remaining four light blue background squares and four 5⅞" blue tonal squares to yield a total of eight 5½" red tonal half square triangles and eight 5½" blue tonal half square triangles. Set aside. (See **Diagram 1**)

Diagram 1

Striped side units

2. Draw a diagonal line on the wrong side of the thirty-two 3" light blue background squares, sixteen 3" red tonal squares, and sixteen 3" blue tonal squares. Place a marked light blue background square right sides together on the corner of a short end of a 5½" x 7½" stripe rectangle, as shown in **Diagram 2**. Stitch on the line, then trim, leaving a ¼" seam allowance. Place another 3" background square on the other corner, overlapping triangle corners, and stitch in the same manner. Repeat to make sixteen units. (See **Diagram 2**)

make 16

Diagram 2

3. In a similar manner, stitch a marked red tonal square to the remaining corners of eight of the units made above. Trim and press as before. Stitch a blue tonal square to each corner of the remaining eight units. (See **Diagram 3**)

make 8 make 8

Diagram 3

Half-Flying Geese units

4. Draw a diagonal line on the wrong side of sixteen 3" red tonal squares and sixteen 3" blue tonal squares. Noting orientation, place a marked square right sides together on one end of a 3" x 5½" light background rectangle. Stitch on the line, then trim, leaving a ¼" seam allowance. Press seam toward triangle. Repeat to make a total of sixteen red half-flying geese units and sixteen blue half-flying geese units, eight in each orientation. (See **Diagram 4**)

make 8 make 8 make 8 make 8

Diagram 4

Corner units

5. Following **Diagram 5** and noting orientation, sew a blue half-square triangle, two red half-flying geese units, and a red 3" square together to make a corner unit. Repeat to make eight red star corner units. Make eight blue star corner units in similar fashion using a red half-square triangle, two blue half-flying geese units and a blue 3" square.

make 8 make 8

Diagram 5

Approx. finished size 51" x 51"

Materials
- 4 5½" squares with patriotic motif centered (may substitute with red and blue tonal)
- ½ yard blue tonal
- ¾ yard stripe
- 1 yard red tonal (includes binding)
- 1 yard light blue background
- 2 yards border stripe
- 57" backing
- 57" batting

Cutting
From each of red tonal and blue tonal:
40: 3" squares
4: 5⅞" squares (if not fussy cutting a center fabric, cut two 5½" squares)

From the red tonal:
6: 2¼" x WOF strips (for binding)

From stripe:
16: 5½" x 7½" rectangles with stripes parallel to long sides

From the light blue background:
8: 5⅞" squares
32: 3" x 5½" rectangles
32: 3" squares

From border stripe:
4: 5½" x 55" lengthwise strips

6. Following the **Block Diagrams**, sew the striped side units, corner units and 5½" center squares together to make a total of four 19½" x 19½" blocks; two red star blocks and two blue star blocks.

Block Diagrams

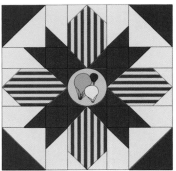

make 2

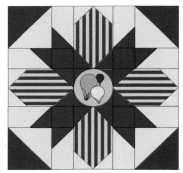

make 2

7. Following the **Quilt Layout Diagram**, sew the four blocks together to make two rows of two blocks each.

Borders

8. With right sides together, center and pin each border strip to the pieced top. Stitch borders to topper using a ¼" seam allowance, stopping and backstitching ¼" from each corner.
9. Using your favorite method, miter the corners of the topper.

Finishing

10. Layer the quilt top and quilt as desired. Join the red binding strips short ends together, then bind as desired.

Tip: We fussy cut a hot air balloon fabric for our quilt top. This size block lends itself to many applications. If using a patriotic color scheme, you might want to use a photo transfer fabric and frame photos of the veterans in your family.

Quilt Layout Diagrams

Flyin' High

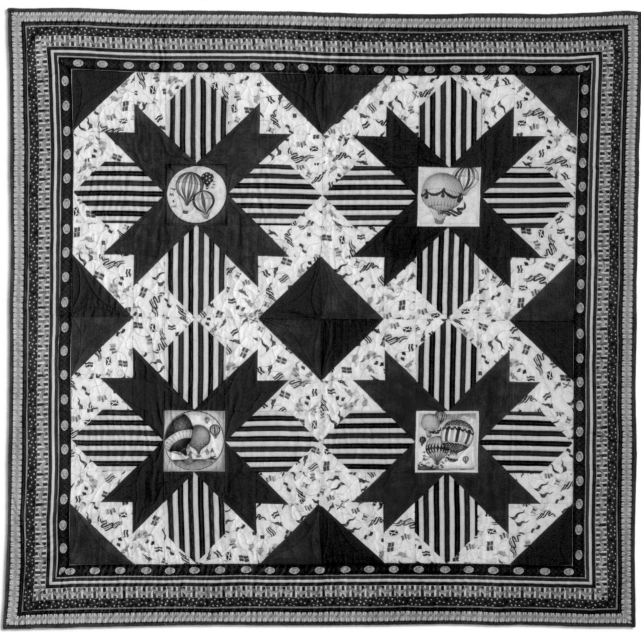

Perfectly Prepared Placemats

These quick-to-stitch placemats look good in a variety of fabric choices.
Why not make a set for yourself and a set for a gift?

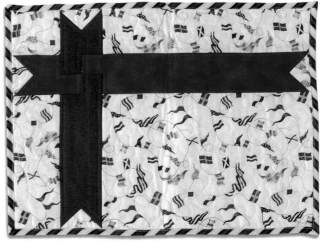

Directions:

Flying Geese units

1. Draw a diagonal line on the wrong side of the sixteen 1¾" red tonal and sixteen 1¾" blue tonal squares. Place a blue square right sides together on each end of a 2" x 3" flag print rectangle. Stitch on the marked lines. Trim excess, leaving a ¼" seam allowance. Press open. Repeat to make eight blue/flag print Flying Geese units. (See **Diagram 1**). Repeat using 1¾" red tonal squares and 2" x 3" flag print rectangles to make eight red/flag print Flying Geese units. (**Note:** These are not traditional Flying Geese units—the added side triangles are not flush to the bottom of the flag print rectangles.)

Four-Patch units

2. Following **Diagram 2,** match up eight 1¾" blue and eight 1¾"red squares with right sides together. Stitch down one side. Press seam allowance toward the blue fabric. Match eight pair units to make four four-patch units. Stitch and then press.

make 8 **make 4** **Diagram 2**

Assembly

3. Following **Diagram 3** and noting orientation, sew a blue/flag print flying geese unit to a 2" x 3" blue tonal rectangle. Sew this unit between a 3½" flag print square and a 3½" x 13" flag print rectangle.

Diagram 3

make 8

make 8

Diagram 1

4. Following **Diagram 4** and noting orientation, sew together a red/flag print flying geese unit, a 2" x 3" red tonal rectangle, a four patch unit, a 3" x 11½" red tonal rectangle and a red/flag print flying geese unit.

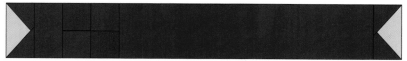

Diagram 4

5. Following **Diagram 5** and noting orientation, sew a 3" x 7½" blue tonal rectangle with a blue/flag print flying geese unit. Stitch this unit between a 3½" x 9" flag print rectangle and a 9" x 13" flag print rectangle.

Diagram 5

6. Following the **Layout Diagram**, sew together the units made in steps 3-5.

finishing

7. Sandwich and then quilt as desired. Trim quilt top so sides and corners are square and straight.
8. Bind as desired using bias stripe strips. (See **Diagram 5**)

Tip: Consider replacing the four-patch unit with a 3" fussy cut square of coordinating fabric or use photo transfers of family members.

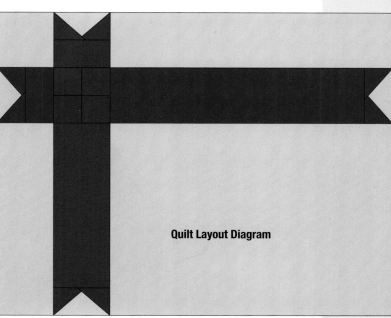

Quilt Layout Diagram

Finished size 14" x 18"

Materials (for four placemats)
- ⅓ yard red tonal
- ⅓ yard blue tonal
- ½ yard stripe
- 1 yard flag print

Cutting
From the red tonal:
4: 3" x 11½" strips
4: 2" x 3" rectangles
24: 1¾" squares

From the blue tonal:
4: 3" x 7½" rectangles
4: 2" x 3" rectangles
24: 1¾" squares

From the stripe:
Enough 2" wide bias strips to make four 80" long strips (for binding)

From the flag print:
4: 9" x 13" pieces
4: 3½" x 13" rectangles
4: 3½" x 9" rectangles
4: 3½" squares
16: 2" x 3" rectangles

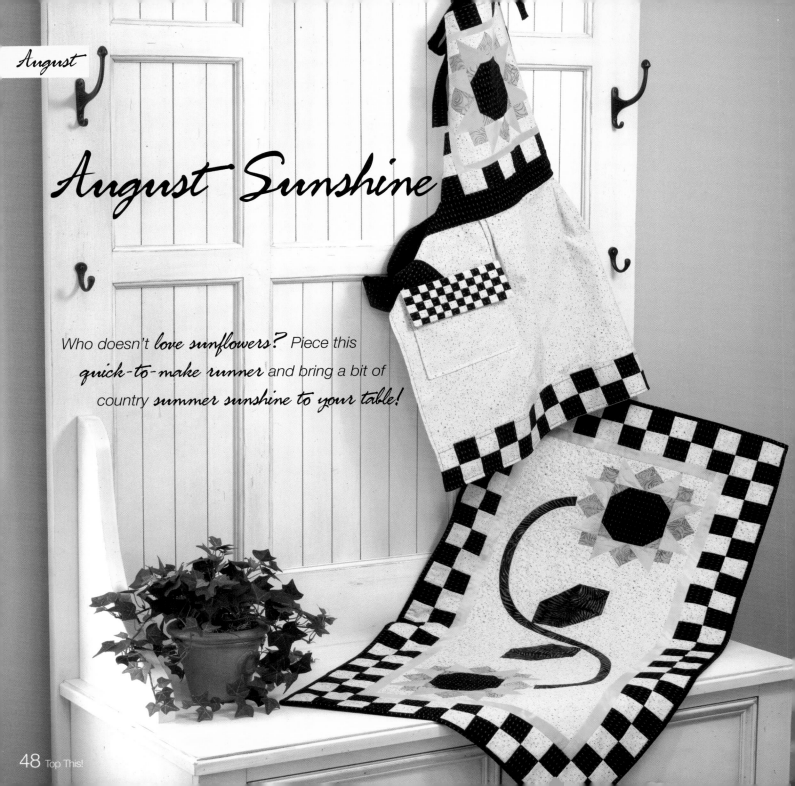

August Sunshine

Who doesn't *love sunflowers?* Piece this *quick-to-make runner* and bring a bit of country *summer sunshine to your table!*

Directions (Table Runner)

Border Units

1. Sew a 2" wide cream strip lengthwise to a 2" wide black fleck strip. Repeat to make four strip sets. Press seams toward the black fleck strips. Square the ends and crosscut sixty-eight 2" wide segments. Set aside. (See **Diagram 1**)

Diagram 1

Center flower units

2. Draw a diagonal line on the wrong side of eight 1½" gold batik print squares. Place a marked square on one corner of the 4½" black fleck square as shown in **Diagram 2**. Stitch on the line. Trim, leaving a ¼" seam allowance. Press the corner open. Repeat on all corners to create two 4½" black fleck center flower units. Set aside.

make 2
Diagram 2

Corner units

3. Pair the remaining eight 1½" gold batik print squares with eight 1½" cream squares. Sew together to create four pairs. Press.

4. Noting orientation, sew a 1½" x 2½" cream rectangle to each of the units made in step 3 as shown in **Diagram 3**. Repeat to make eight 2½" x 2½" corner units, four in each orientation.

make 4 make 4
Diagram 3

Side units

5. Sew a 3¼" cream quarter square triangle to adjoining sides of a 1⅞" gold batik square, with the cream triangle points extending beyond the square. Sew, using a ¼" seam allowance. Press the seam allowance toward the cream triangles. Repeat to make eight units. (See **Diagram 4**)

make 8
Diagram 4

6. Using the 2⅞" yellow tonal half-square triangles, sew a triangle to adjoining sides of the gold batik/cream triangle. Press. Make a total of eight side units. (See **Diagram 5**)

make 8
Diagram 5

Finished size 22" x 40"

Materials

- ¼ yard or fat quarter gold batik print
- Quarter or half yard green batik
- ¼ yard yellow tonal
- ⅞ yard black fleck
- 1 yard cream background
- 27" x 45" backing
- 27" x 45" batting

Cutting
From the gold batik print:
16: 1½" squares
8: 1⅞" squares

From the green batik:
2: 1¼" wide bias strips (for sunflower stem).
2: 4½" squares.

From the yellow tonal:
8: 2⅞" squares, cut once diagonally to create sixteen half-square triangles
3: 1¼" x WOF strips (for inner border); recut one strip into two 1¼" x 12½" strips
2: 1¼" x 12½" pieces

From the black fleck:
2: 4½" squares
4: 2" x WOF strips (for checkerboard border)
4: 2¼" x WOF strips (for binding)

From the cream background:
2: 4½" x 14½" pieces
2: 4½" x 8½" pieces
3: 2½" x 4½" pieces
4: 3¼" squares, cut twice diagonally to make sixteen quarter-square triangles
4: 2½" squares
8: 1½" x 2½" rectangles
8: 1½" squares
4: 2" x WOF strips (for checkerboard border)

Sunflower block assembly

7. Using the **Layout Diagram** as a guide, stitch the center flower, corner and side units together to make two 8½" x 8½" sunflower blocks. Press, then set two blocks aside.

Green leaf blocks

8. Draw a diagonal line on the wrong side of the four 2½" cream squares. Place a square right sides together on a 4½" green batik square as seen in **Diagram 6**. Stitch on the line. Trim, leaving a ¼" seam allowance. Press the corner open. Repeat on the opposite corner. Make two matching blocks.

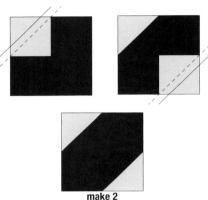

make 2
Diagram 5

Assembly

9. Following **Layout Diagram** and noting orientation, sew three 2½" x 4½" cream pieces alternately with the two green leaf blocks made above. Stitch a 4½" x 14½" cream piece to each long side of this unit. Press seams toward cream piece.

10. Sew a 4½" x 8½" cream rectangle onto one side of each sunflower block. Press seams toward cream rectangles.

11. Sew the sunflower block/cream rectangle units to each end of the unit made in step 10, offsetting the sunflowers to make the 12½" x 30½" runner center.

12. *Inner Border.* Sew a 1¼" x 12½" yellow batik strip to each end of the runner. Measure lengthwise through the center of the runner and then cut the remaining two 1¼" x WOF yellow tonal strips to that length. Sew to each side of the runner.

13. *Checkerboard border.* Sew 21 of the 2" wide segments cut in step 1 together to make one checkerboard border strip. Repeat to make two strips. Sew to each long side of the runner. (**Note:** The same color should meet the inner border on all four corners.) Sew 13 segments together to make a checkerboard border for each end. Pay attention to the color pattern.

14. Sew the two green batik bias strips together to make one long strip. Place the strip on your pressing surface wrong side up. Fold both raw edges toward the center and then press along the entire length. Arrange the bias stem in a gentle *S* shape, extending from one sunflower to the other and passing through the center 4½" x 8½" cream rectangle. When satisfied with placement, pin in place. Hand or machine applique the bias stem onto the topper.

Finishing

15. Layer and quilt the topper as desired.
16. Join the 2¼" black fleck strips end to end and bind as desired.

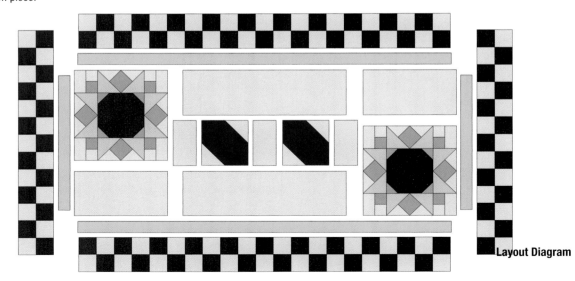

Layout Diagram

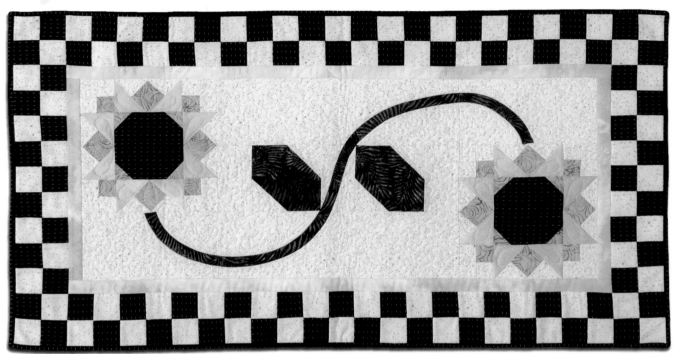

August Sunshine Apron

Why limit this *delightful project* to the table? *Spread the cheer* from this *pieced sunflower* through all of your kitchen activities with this *lovely apron*.

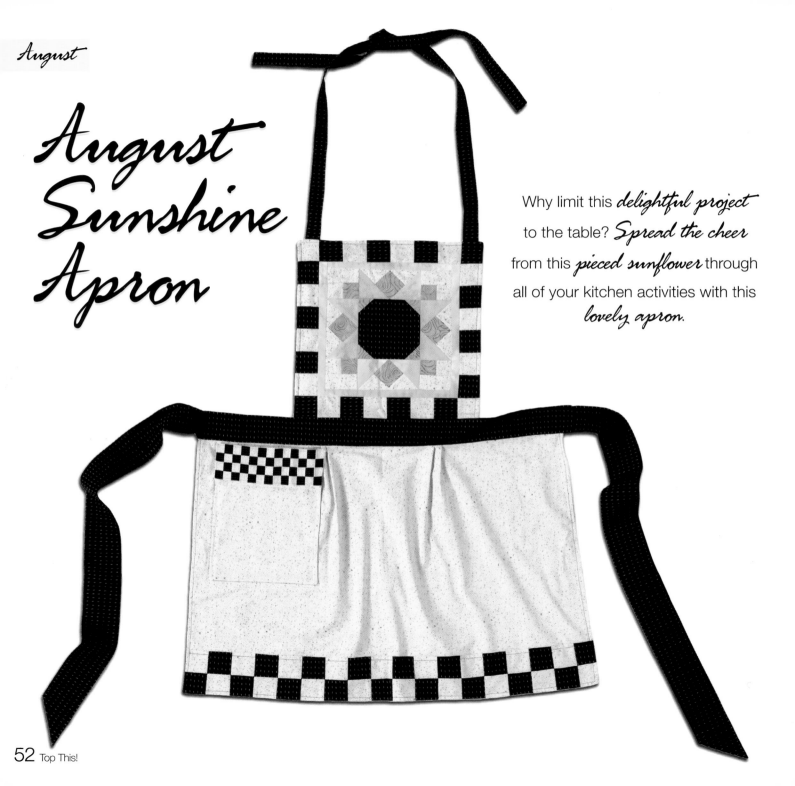

Directions

1. Follow steps 2 through 8 for the August Sunshine runner to make one sunflower block.

2. Sew a 1" x 8½" yellow tonal strip to the top and bottom of the sunflower block. Press seams toward the yellow fabric. Sew a 1" x 9½" yellow tonal strip to each side of the sunflower block. Press as before. Set aside.

Two-patch Segments

3. Sew a 2" wide cream strip lengthwise together with a 2" wide black fleck strip. Repeat to make two strip sets for the checkerboard border. Square off the end, then crosscut thirty-two 2" two-patch segments. (See **Diagram 1**)

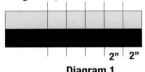 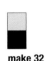

2" 2" make 32

Diagram 1

Sunflower Block Border

4. Join together 18 two-patch segments to make the checkerboard border for the bottom edge of the apron, as shown in **Diagram 2**. Sew to the 14½" x 35½" cream piece.

Diagram 2

5. Join three two-patch segments short ends together to make an alternating black fleck/cream strip. Make two. Sew one strip to the top of the sunflower block and the other strip to the bottom. Press seams toward the inner border.

6. Join four two-patch segments short ends together to make an alternating black fleck/cream strip. Make two. Sew a strip to each side of the sunflower block, taking care to keep the alternating pattern of color. Press as before to finish the sunflower apron bib unit.

Pocket

7. Make two sets of strata for the pocket trim. For strata A, sew five 1" x 10" strips lengthwise together in the following order: cream, black fleck, cream, black fleck, cream. Press. Make strata B in following order: black fleck, cream, black fleck, cream, black fleck. Press. (See **Diagram 3**)

A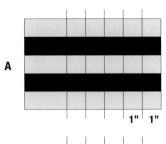

1" 1"

B

1" 1"

make 7 make 6

Diagram 3

Materials
- Fat eighth gold batik print
- Fat eighth yellow tonal
- 1 yard black fleck
- ⅞ yard cream
- 1 yard lining fabric

Cutting
From the cream:
1: 14½" x WOF strip, recut one 14½" x 35½" piece (for apron skirt) and five 1" x 10" strips (for A & B Strata)
1: 7½" x WOF strip; recut into one 7½" x 9½" piece (for pocket) and two 3 1/4" squares, then cut twice diagonally; from remainder, cut four 1½" x 2½" rectangles and four 1½" squares
2: 2" x WOF strips (for checkerboard border)

From the black fleck:
2: 5" x 30" strips (for waistband ties)
1: 4½" square
2: 2" x WOF strips
2: 2½" x WOF strips; recut to 2½" x 27" strips (for neck straps)
1: 5" x 35½" strip (for waistband)
5: 1" x 10" (for A & B Strata)

From the gold batik print:
8: 1½" squares
4: 1⅞" squares

From the yellow tonal:
4: 2⅞" squares, cut once diagonally
2: 1" x 8½" strips
2: 1" x 9½" strips

From the lining fabric:
1: 17½" x 35½" piece
1: 12½" x WOF strip; recut one 12½" square (for apron bib) and one 6½" x 7" piece (for pocket)

8. Square the ends of each strata. Cut seven 1" wide segments from strata A and six 1" wide segments from strata B. Sew the segments together, beginning and ending with a strata A segment, alternating the strata to form a mini checkerboard pattern. This unit should measure 3" x 7". (See **Diagram 4**)

Diagram 4

9. With right sides together, sew the mini checkerboard unit to the 6½" x 7" pocket lining piece. Press seams toward the lining fabric.

10. Place the 7½" x 9½" cream pocket fabric right sides together with the lining/mini checkerboard fabric. Stitch around the pocket and lining, leaving about 2" unstitched for turning on the short end of the cream fabric (opposite the mini checkerboard).

11. Clip the corners and turn right side out. Stitch in the ditch between the mini checkerboard and lining fabric.

Apron Base

12. Layer the apron skirt with the checkerboard bottom border right sides together with the 17½" x 35½" lining fabric piece. Leaving an opening for turning (about 6-8 inches), sew around apron. Turn right side out and press. Baste opening closed within seam allowance. Topstitch ¼" from sides and bottom of apron.

13. Following **Diagram 5,** position the pocket on the left side of the apron, about 5" above the top of the checkerboard border and 1½" from the left side. Pin in place through all layers. Lift the mini checkerboard and then sew the pocket to the apron using a scant ¼" seam allowance and backstitching to secure at beginning and end. (Be sure bottom seam catches space from turning the pocket right side out.)

Diagram 5

Neck Straps

14. Fold each 2½" x 27" black fleck strip right sides together and sew down the long side and one short edge. Turn right side out and press, centering the seam. Using matching thread, topstitch a scant ¼" from the edge down both long sides and finished short end. Finish both neck straps in the same manner.

15. Position the neck straps on the sunflower apron bib unit, aligning the inside of the strap with the seam between the first and second checkerboard squares. Baste in place. (See **Diagram 6**)

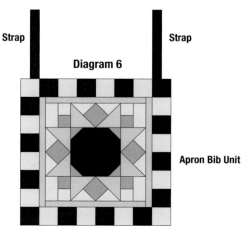

Strap **Diagram 6** Strap

Apron Bib Unit

16. Place the 12½" square bib lining right sides together with the sunflower apron bib unit with neck straps made above. With neck ties at top of unit, and being careful not to catch them in the seam, stitch around the four sides, leaving an opening for turning (about 4-6 inches) in the bottom of the apron bib. Clip corners as needed, then turn right side out. Topstitch around the sides and top of bib.

Waistband and ties

17. Fold each 5" x 30" black fleck waistband tie strip in half lengthwise with right sides together. Stitch down the long side and one short end. Turn right side out and press, centering the seam. Topstitch down both long sides and finished short end. Make both waistband ties in the same manner.

18. Fold the 5" x 35½" black fleck waistband strip in half lengthwise with right sides together. Stitch down the long side. Turn right side out and press, centering the seam of the waistband.

19. Center the right side of the apron skirt onto the seam side of the waistband, overlapping the edge by ⅜". Pin in place. Topstitch waistband ¼" from edge, catching the top of the apron skirt.

20. Center the apron bib right side down on the seam side of the waistband, overlapping the edge by ⅜". Pin in place. Topstitch waistband ¼" from edge, catching the bottom of the apron bib.

21. Fold each unfinished end of the waistband in ½". Insert ½" of the unfinished end of each waistband tie into waistband. Topstitch to enclose waistband ties within waistband.

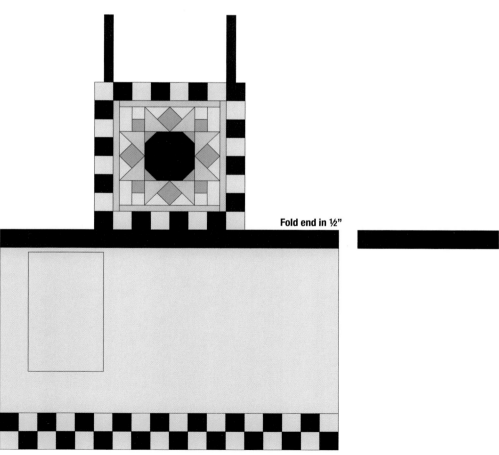

Insert unfinished end in 1½"

Fold end in ½"

Diagram 7

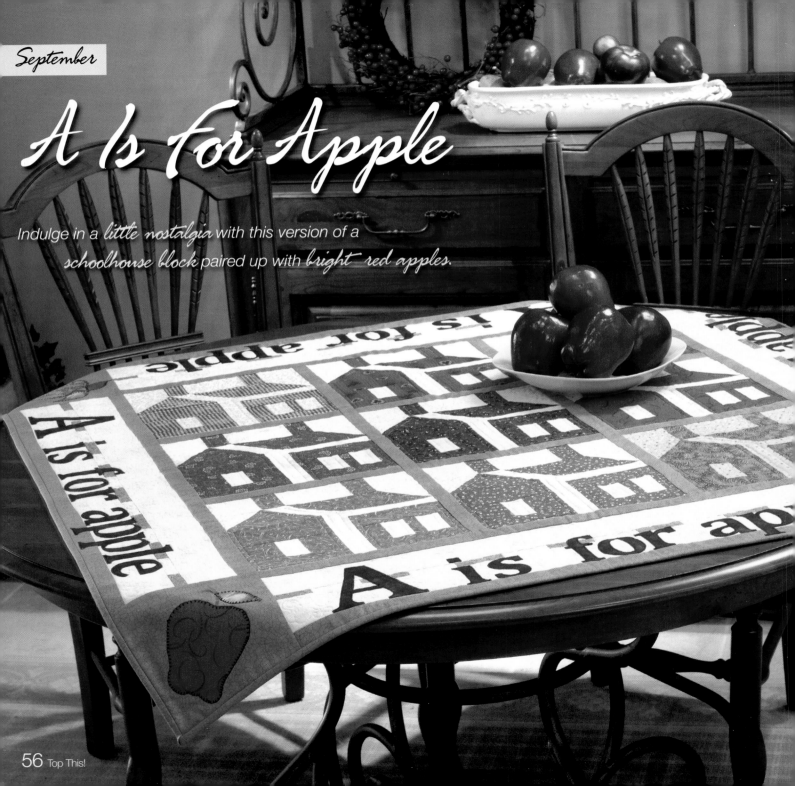

A Is For Apple

Indulge in a little nostalgia with this version of a schoolhouse block paired up with bright red apples.

Directions

Note: Refer to lettered diagram as needed when constructing the schoolhouse blocks. (See **Diagram 3**)

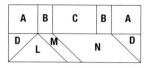

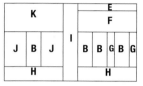

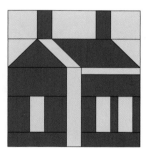

Diagram 3

1. Decide which tan fabric will go with which red fabric or make it random and scrappy. If you decide to keep the same tan with the same red, then stack the fabrics according to the lettered designation to reduce confusion.

Upper portion of Schoolhouse Block

2. Sew the first row: A to red B, then C to red B, and end with A.

3. Sew second row: Long side of triangle D to triangle L. Sew the long side of the M to the right side of the L triangle. Sew another triangle D to N. Sew the D/N unit to the D/L/M unit. Line the units up carefully. If in doubt, baste together, then open and check for accuracy. If necessary, remove basting and reposition.

4. Sew row 1 and row 2 together as seen in **Diagram 3**.

Finished size 40" x 40"

Materials
- Fat eighth each of nine different red prints
- Fat eighth each of nine different tan prints
- ½ yard black marble
- ¾ yard beige
- 1½ yard medium blue
- Scraps of green (for leaves)
- Scraps of brown (for stems)
- 1 yard fusible web
- 46" of batting
- 46" of backing

Cutting

From each of the red prints:
2: 1" x 2½" rectangles (for G)
3: 1½" x 2½" rectangles (for B)
2: 2" x 2½" rectangles (for J)
1: 2½" x 7½" rectangles (for N, with right side up, line up 45° angle of ruler along bottom of strip and cut from lower right up toward center; make a parallel cut at other end from upper left toward center bottom as shown in **Diagram 1**
1: 2⅝" x 5¼" rectangle; using 45° angle on ruler, cut from lower right toward upper center and from lower left to upper center (for L) **Diagram 2**
1: 2½" x 4½" rectangle (for K)
2: 1½" x 4½" rectangles (for H)
1: 1¾" x 4½" rectangle (for F)

From each of the tan prints:
2: 2½" squares (for A)

3: 1½" x 2½" rectangles (for B)
1: 2½" x 3½" rectangles (for C)
1: 1½" x 5½" rectangles (for I)
1: 1¼" x 5½" (for M using same method as shown in **Diagram 1**, cut parallel 45° angles at both ends of M strip—angles will be in opposite directions than for N)
1: 1¼" x 4½" (for E)
2: 2⅞" squares, cut once diagonally (for D)

From the black marble:
Trace "A Is For Apple" four times on fusible web; fuse onto wrong side of black marble fabric and cut out neatly; do not remove backing paper until ready to fuse in place.

From the beige:
7: 2½" x 5" rectangles
8: 2½" x WOF strips (for the border)

From the medium blue:
4: 6½" squares
8: 2½" x 5" rectangles
10: 1¼" x WOF strips
6: 1¼" x 9½" strips
5: 2½" x WOF strips (for binding)

From the scraps:
Trace 4 apples onto fusible web; using scraps from cutting out the schoolhouses, choose four different reds and fuse the traced apples onto the wrong side. Cut out and set aside. Leave the paper on until ready to fuse into place. Follow the same procedure for apple leaves and stems.

Diagram 1

Diagram 2

Lower portion of Schoolhouse Block

5. Sew a J onto both long sides of a tan B. Press.

6. Sew an H to the bottom long side of the J/B unit from step 5. Sew a K to the top of the unit. Sew an I to the right side. Set aside.

7. Sew the following together down their long sides: red B, tan B, G, tan B, G. Press.

8. Sew an H to the bottom of the unit made in step 7. Sew an F to the top of the unit made in step 7. Sew an E to the top of the F. Press.

9. Sew the unit made in step 8 to the right side of the I piece of the unit finished in step 6. Press. Sew the entire bottom portion of the schoolhouse to the upper part finished in step 4. Complete all nine 9½" x 9½" schoolhouse blocks in the same manner. Set aside.

Layout

10. Decide on the layout of the schoolhouse blocks and position them into three horizontal rows of three blocks each. Sew a 1¼" x 9½" medium blue sashing strip to the bottom of the three schoolhouse blocks in the top horizontal row and the three schoolhouse blocks in the center horizontal row.

11. Sew the schoolhouse blocks together in vertical rows. Cut two 1¼" sashing strips to 29" long (or the length of the row when measured through the center lengthwise). Sew two 1¼" x 29" sashing strips alternately with the three vertical schoolhouse block rows. Press topper.

Pieced Border

12. The pieced border is meant to represent the tablets on which primary students learn to print. Sewing down the long sides, make a strata beginning with the eight 2½" x 5" medium blue rectangles and alternating with the seven 2½" x 5" beige rectangles. Press seams toward the blue rectangles. Square off end. Crosscut four 1" wide segments. (See **Diagram 4**)

Diagram 4 1"

13. Measure topper through the center for width and length. Measurements should be approximately 29". Cut eight 2½" x WOF beige strips to 29" in length or the length required to fit your topper. Cut eight 1¼" x WOF medium blue strips to the same length.

14. Sew the 1¼" wide medium blue strips long sides together with the 2½" beige strips to make a total of eight strip sets.

15. Sew a strata segment between two of the units completed above, aligning strata segment with beige fabric and allowing strata segment to extend about ½" from each end. Trim. Repeat to make four border units in this manner. (See **Diagram 5**)

Diagram 5

16. Sew a completed border unit to each side of the schoolhouse block topper. Press seam allowance toward border. Sew a 6½" medium blue square to each end of the remaining border units. Press seam allowance toward border units. Stitch to the remaining sides of the topper. Press.

17. Lay out the A Is For Apple lettering on one border at a time. Remove the backing paper and fuse in place, being sure to leave at least ¼" below the leg of the letter P so that the binding will not be sewn over it. Machine appliqué raw edges.

18. Position apples with leaves and stems as desired on the four corner medium blue squares. Remove backing paper and fuse in place. Machine appliqué raw edges.

Finishing

19. Layer and quilt as desired. You may choose to buttonhole stitch the fused appliqués either by hand or machine.

20. Bind as desired using the five 2½" medium blue strips.

Layout Diagram

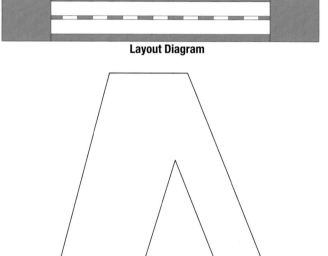

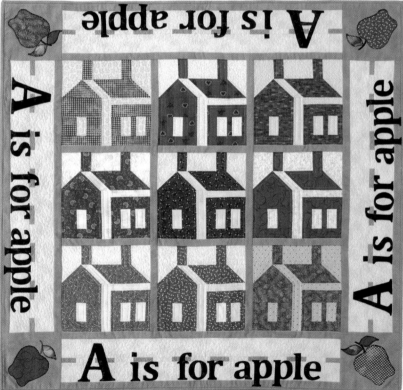

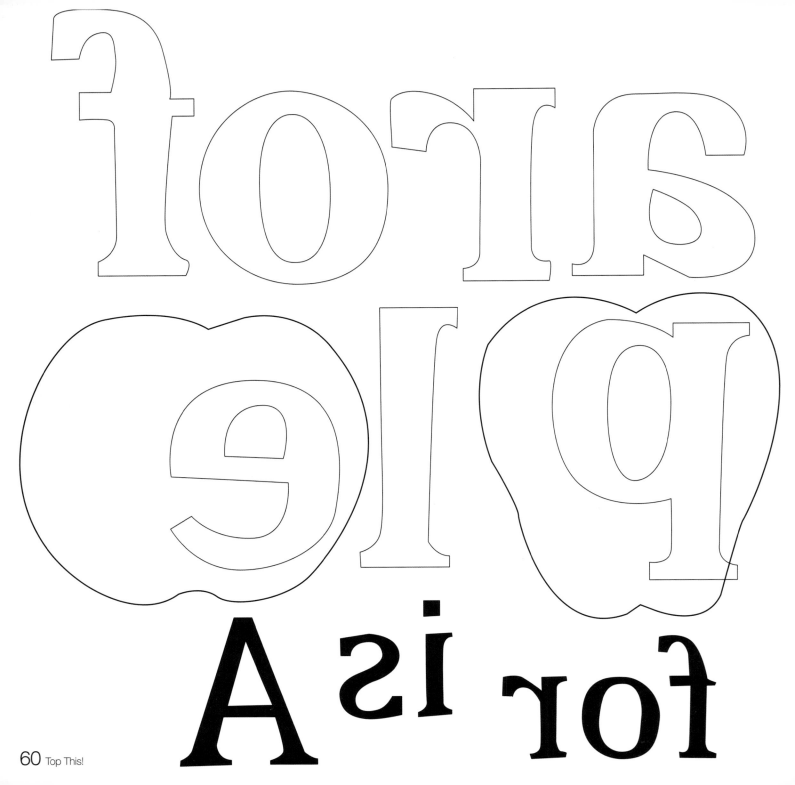

"A Is For Apple" Placemats

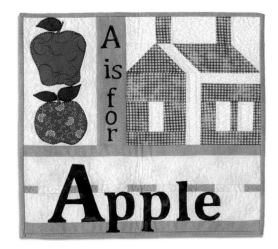
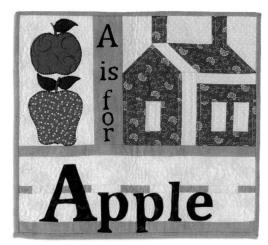

Finished size 16½" x 16½"

Materials (for four placemats)
- Scraps of green and brown
- Eight 6" squares of red
- 1 yard black marble print
- Fat eighth each of four different red prints
- Fat eighth each of four different tan prints
- ⅔ yard beige
- ⅞ yard medium blue
- 1 yard fusible web
- 1 yard backing
- 1 yard batting

Cutting

From the Red prints:
Cut as per instructions for the "A is for Apple" Table Topper

From the Tan prints:
Cut as per instructions for the "A is for Apple Table Topper

From the Beige:
4: 2½" x WOF strips, then recut into eight 2½" x 16½" pieces
4: 2½" x 5" rectangles (for strata unit)
4: 5¼" x 9½" rectangles

From the medium blue:
4: 2½" x 9½" rectangle
5: 2½" x 5" rectangles (for strata unit)
8: 2¼" x WOF strips (for binding)
4: 1¼" x WOF strips

From the fusible web:
Trace 8 apples
Trace 8 stems and desired number of leaves
Following instructions for the "A Is For Apple" Table Topper, fuse onto wrong side of fabric. Cut out. Set aside until placemat is assembled.
Trace A is for Apple onto fusible web. Note that the letters in "A is for" are smaller than for the topper. Fuse onto wrong side of black marble. Cut out. Set aside until placemat is assembled.

Directions

1. Follow instructions for the "A Is For Apple" Table Topper project to cut and assemble four schoolhouse blocks.
2. Make the pieced border as for the "A Is For Apple" Table Topper project, this time using five 2½" x 5" medium blue rectangles and four 2½" x 5" beige rectangles.
3. Sew the 2½" x 9½" medium blue strip right sides together with the long side of the 5¼" x 9½" beige piece. Press seam toward the medium blue fabric.
4. Sew the schoolhouse block to the right side of the medium blue strip. Press seam toward the medium blue fabric.
5. Sew the border unit to the bottom of the unit made in step 4. Press seam toward the medium blue fabric.
6. Fuse apples with stems and leaves onto the 5¼" x 9½" beige rectangle, leaving at least ¼" at the top and left side for seam allowance. Fuse the smaller version of the letters, "A Is For" vertically down the 2½" wide medium blue strip. Center the word "Apple" on the border unit at the bottom of the placemat being sure to leave ¼" below the leg of the letter P so binding will not be seen over it. Fuse into place.

Finishing

7. Layer and quilt as desired. You may choose to use a hand or machine buttonhole stitch around the apples and letters.
8. For each placemat, join two 2¼" x WOF strips, and bind as desired.

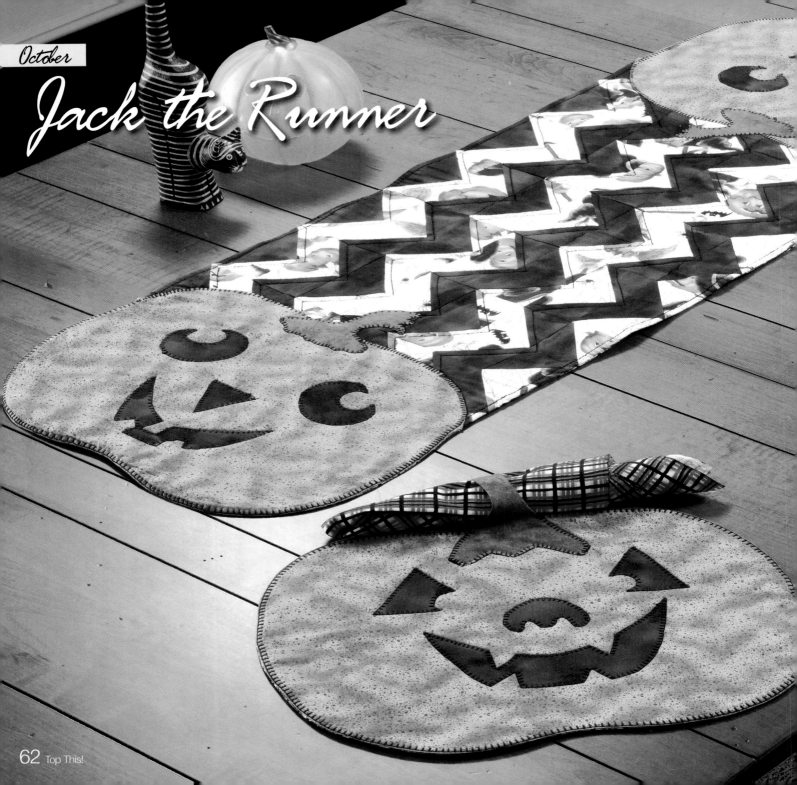

Make this humorous Halloween runner and matching placemats for the little ghouls in your family.

Finished size 14" x 50"

Materials
- Scrap of brown (about 6" square, for stem)
- ½ yard orange (for pumpkin shapes)
- ⅝ yard marbled black
- ⅝ yard Halloween print
- ⅝ yard batting
- ⅝ yard backing
- ¼ yard fusible web
- Paper (such as newsprint, at least 11" x 17", to draw pumpkin shape)
- Even Feed Foot
- 30-weight black thread

Cutting
From the marbled black:
28: 2½" x 4½" rectangles
42: 2½" squares
Reserve remainder for face shapes

From the Halloween print:
21: 2½" x 4½" rectangles
56: 2½" squares

Directions

Pumpkin and Stem Shapes

1. Measure and mark a rectangle on the drawing paper that measures 11" x 15". Freehand draw a pumpkin shape within the rectangle. Cut out neatly. Use the pumpkin pattern to trace and cut out two pumpkins from the orange fabric.

2. Trace the stem pattern twice onto fusible web. Cut out, leaving approximately ¼" outside of the drawn lines. Fuse the stem shapes onto the wrong side of the brown fabric. Cut out neatly on the drawn lines. Set aside.

Flying Geese Units

3. Draw a diagonal line on the wrong side of the forty-two 2½" marbled black squares. Referring to **Diagram 1**, place a square right sides together on each end of a 2½" x 4½" Halloween print rectangles. Sew on the drawn lines. Trim excess, leaving a ¼" seam allowance. Press seams toward marbled black fabric. Repeat to make a total of twenty-one Halloween print Flying Geese units.

4. Following **Diagram 1**, repeat with the fifty-six 2½" Halloween print squares and twenty-eight 2½" x 4½" marbled black rectangles to yield twenty-eight marbled black Flying Geese units.

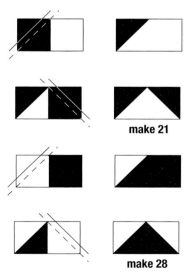

make 21

make 28

Diagram 1

Assembly

5. Following the **Layout Diagram** and noting orientation, sew the Flying Geese units alternately into seven rows of seven units each.

6. Baste pumpkin shapes on each narrow end of the runner with the shoulders of the pumpkin approximately 3" from the edge of the runner.

Finishing

7. Layer the runner top right sides together onto the backing fabric, then on top of batting. Press. Trim backing and batting even with the pieced top. Leaving a gap on one side for turning, sew around the runner using an even feed foot and a ¼" seam allowance. Trim excess from curves or as needed. Turn right side out through the opening. Push out the seam edge and press. Hand stitch the opening closed.

8. Fuse the stems onto the pumpkins. If you desire a Jack O' Lantern face, trace the shapes provided or freehand draw your own facial features onto fusible web. Cut out from the black scraps, and fuse in place.

9. Use 30-weight black thread to quilt the runner as desired. You may choose to use a buttonhole stitch around the edge of the pumpkin and around the stem and face shapes. Be sure to quilt or topstitch around the edge of the pumpkin and remove the basting stitches.

Layout Diagram

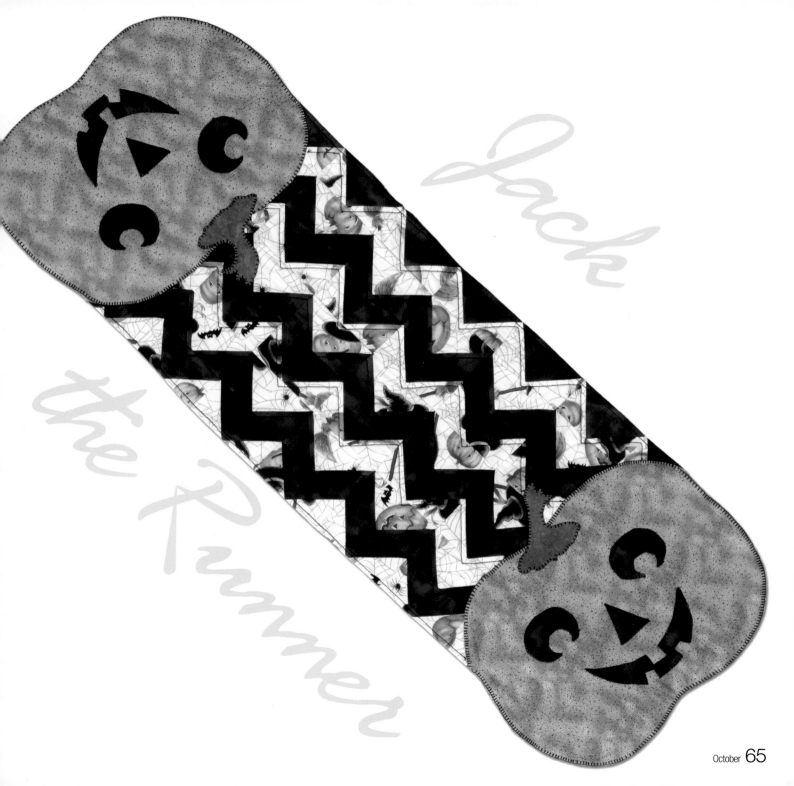

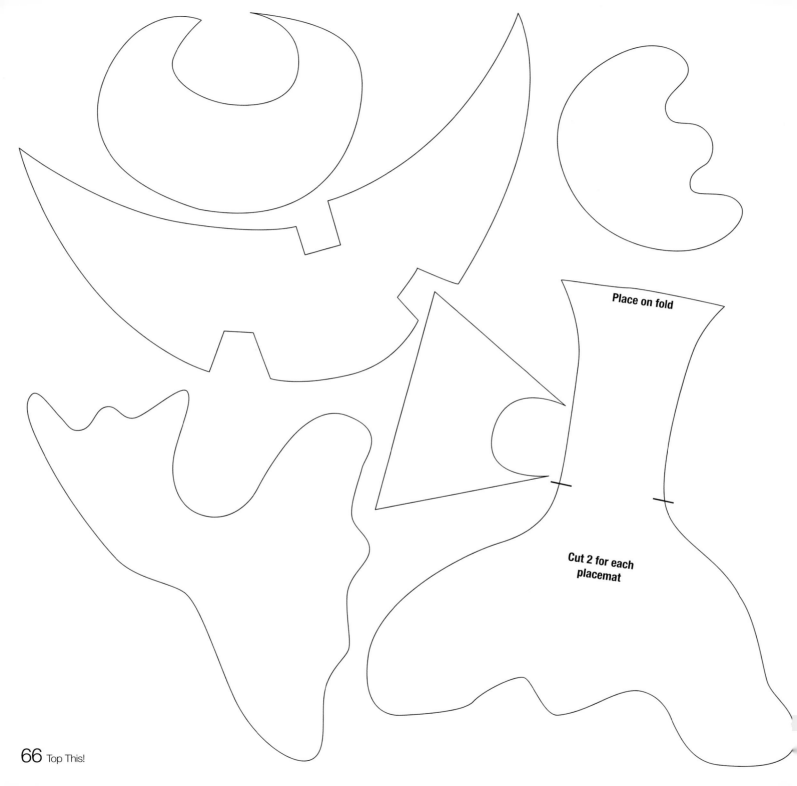

Place on fold

Cut 2 for each
placemat

Jack the Mat

Make matching Jack O' Lantern placemats when you make the Halloween runner. If making these for children, let each child design the face for their placemat!

Finished size 11" x 14"

Materials (for one placemat)
- Fat quarter orange
- Fat quarter backing
- Equal size thin batting
- Scraps of black (for the face)
- ⅛ yard brown
 (for stem/napkin holder)
- Fusible web

Directions

1. With fabric edges even, layer the pumpkin fabric right sides together with the backing fabric. Place on top of the batting. Use the pumpkin pattern from the Jack the Runner project or make one slightly larger (maximum size 12" high by 18" wide). Pin the pattern through all three layers. Cut out neatly.

2. Using an even feed or walking foot, stitch all the way around the pumpkin shape. Trim excess to ¼" from the stitching. Clip the curves and corners.

3. Lift the orange fabric away from the backing fabric where you want to place the mouth of the Jack O' Lantern face. Use scissors to snip an *X* shape, keeping it as small as possible with each leg of the X measuring about 1" long. Carefully turn the placemat right side out through the *X*. You may need to use a long narrow object, such as a table knife or knitting needle, to smooth the placemat flat and to push the seams and corners smooth.

4. Trace the face shapes onto fusible web. Cut out neatly, making sure that the Jack O' Lantern mouth is large enough to cover the turning hole. Arrange the shapes on the Jack O' Lantern. Fuse in place.

5. Use heavyweight black thread with a decorative or buttonhole stitch to sew around the facial features. Stitch around the edge of the pumpkin shape close to the edge.

6. Trace the napkin ring stem onto brown fabric. Cut out two stem pieces and place right sides together. Sew down each narrow side to mark on pattern. Turn right sides out and press. Fold in half so the bottom edges match exactly. Unfold slightly and place the bottom of the stem on the top of the placemat so the stem lines up on the back and top of the placemat, creating a loop. Stitch in place using heavyweight black thread. The resulting loop made by the stem is a napkin holder.

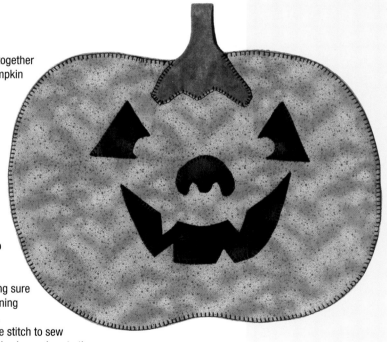

Leaf It to Me

Autumn is a season of *wealth for the senses* with its mild temperatures, *brightly colored leaves,* and *fragrant spicy pies.* Make it last just a little longer by stitching this seasonal runner!

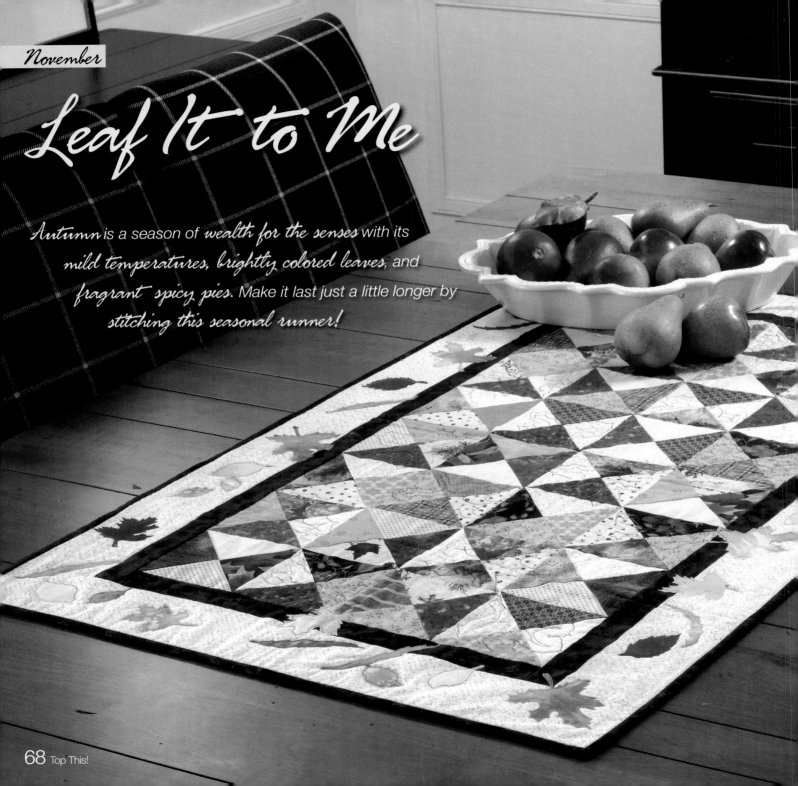

Directions
Quarter square triangle blocks

1. Draw a diagonal line on the wrong side of the 5¼" light print squares. With right sides together, pair sixteen light print squares and sixteen medium to dark autumn print squares. Try to be very random—do not pair the same prints more than once. Using a scant ¼" seam allowance, stitch on both sides of the drawn line. Cut apart on the drawn line and press seams toward the darker fabric. Repeat to yield 32 half-square triangle units. (See **Diagram 1**)

Diagram 1

2. Use the rotary cutter and ruler to cut the half-square triangle units diagonally in half in the opposite direction of the seam. (See **Diagram 2**)

Diagram 2

3. Using a mix-and-match scrappy approach and matching up the quarter-square halves so that no two are alike (if possible), stitch together as shown in **Diagram 3** to make 32 quarter-square units. Each unit should measure 4½".

make 32

Diagram 3

Finished size 24" x 40"

Materials
Note: This project looks best when made from a variety of scraps. Be sure to add some unexpected colors, like deep purple or a rich burgundy, as well as chocolate browns and rust.

- Sixteen 5¼" squares of medium to dark autumn prints
- Sixteen 5¼" squares of light prints
- ½ yard marbled black
- ½ yard of light autumn print
- 24-40 4" squares of autumn color (for fused leaves)
- 30" x 46" batting
- 30" x 46" backing

Cutting
From the black marble:
2: 1½" x WOF strips
 (for inner border)
2: 1½" x 16½" strips
 (for inner border)
4: 2¼" x WOF strips
 (for binding)

From the light autumn print:
4: 3½" x WOF strips
 (for outer border)

Assembly

4. Sew the quarter-square units together into four rows of eight units each in such a manner that the medium and dark autumn colors are vertical in one block and horizontal in the next. Press.

5. Sew a 1½" x 16½" black marble strip to each short end of the runner. Measure through the center for length, then cut two of the 1½" x WOF black marble strips to size (approximately 32½" long). Sew to each long side.

6. Measure through the center crosswise for width. Cut two outer border pieces to that length and sew to each end. Measure lengthwise for outer border measurements. Cut two outer border pieces to appropriate length and sew to each side.

7. Using leaf templates, trace 24 to 40 different leaves onto the fusible web. Use scraps of several different autumn colors; batik fabrics work especially well. Following manufacturer's instructions, fuse onto the wrong side of the leaf color scraps and then cut out neatly. Arrange the leaves around the edge of the runner. Fuse in place.

Finishing

8. Layer and quilt as desired. When quilting, stitch around the inner edge of each appliquéd leaf.

9. Join the black marble binding strips and bind runner as desired.

Tip: Cut leaf shapes from freezer paper and then press onto runner in a random fashion. Use free motion quilting techniques to quilt around the freezer paper leaves. They peel up easily and may be repositioned several times to use as a quilting template.

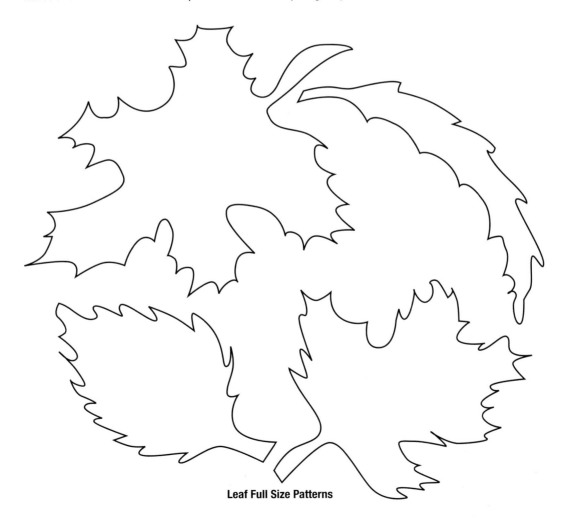

Leaf Full Size Patterns

Layout Diagram

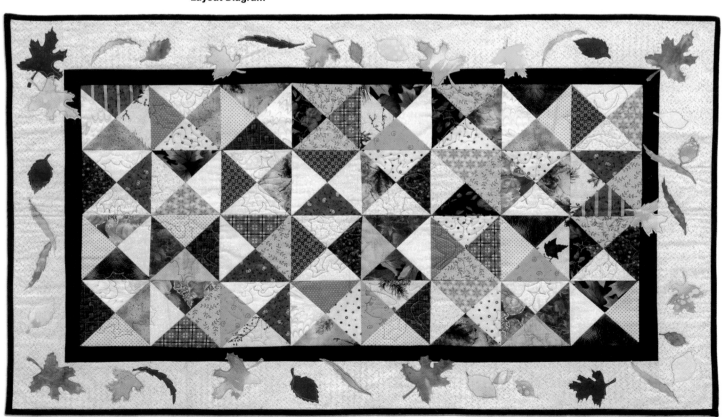

Leaf It to Me

Can't Wait 'til Christmas

The *scrappy technique* employed in *Leaf It to Me* is just as *effective in this version*,
which calls to mind Christmas cookies complete with frosting and sprinkles!

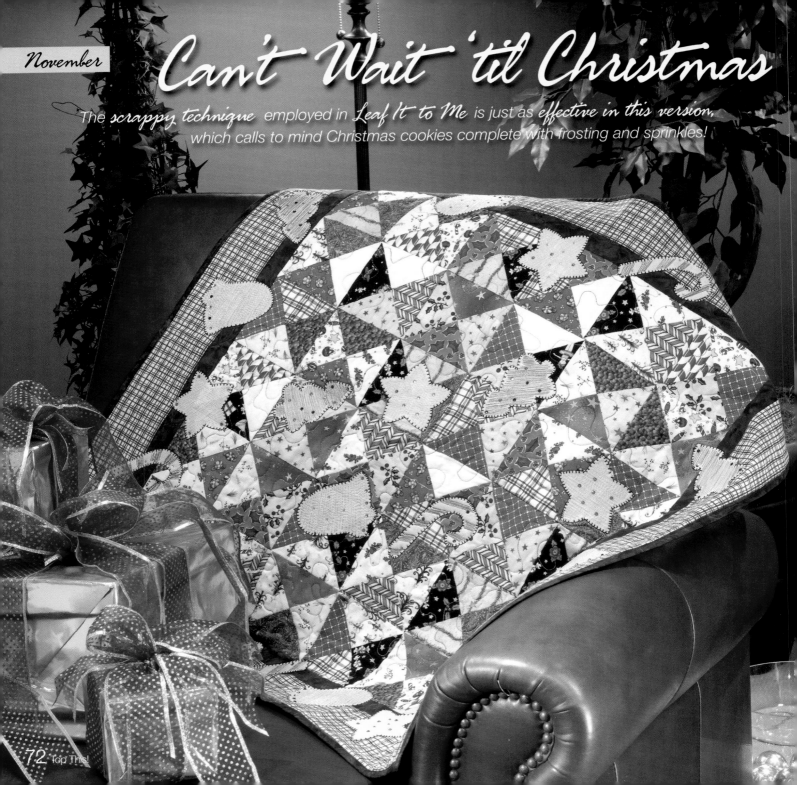

Directions

1. Follow steps 1-3 in assembly instructions for Leaf it to Me to make a total of 36 quarter square triangle units.

2. Sew the blocks together in six rows of six blocks each in such a manner that the medium and dark Christmas prints are vertical in one block and horizontal in the next. Press.

3. Measure through the center crosswise (should be 24½"). Cut two 1½" x WOF dark green strips to that length and attach to sides of topper. Measure through center lengthwise. Cut two 1½" x WOF dark green strips to that length and attach to top and bottom. Repeat for outer borders, using the 3½" x WOF red/cream plaid strips.

4. Instead of leaf shapes, trace a variety of cookie shapes onto the fusible web. Fuse the shapes in a random fashion onto the pieced table topper.

5. Use high-sheen embroidery thread to free motion quilt the cookie shapes to simulate frosting. Apply hot fix crystals as desired for sprinkles.

Finishing

6. Layer and quilt as desired.

7. Bind as desired using the four 2¼" dark green marble strips.

Finished size 32" x 32"

Materials
- Eighteen 5¼" squares of medium to dark Christmas prints
- Eighteen 5¼" squares of white on white and light Christmas prints
- ½ yard dark green marbled
- ½ yard red/cream plaid
- ¼ yard beige marble or batik
- ¼ yard fusible web
- 1 yard each of backing and lightweight batting
- High-sheen embroidery thread (optional)
- Hot fix crystals or seed beads (optional)

Cutting
From the dark green marble:
- 4: 1½" x WOF strips (for inner border)
- 4: 2¼" x WOF strips (for binding)

From the red/cream plaid:
4: 3½" x WOF strips

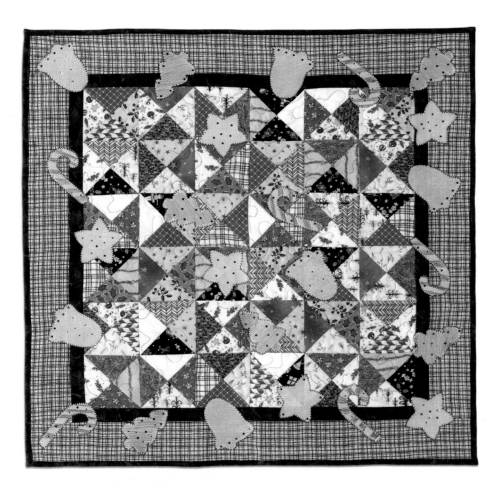

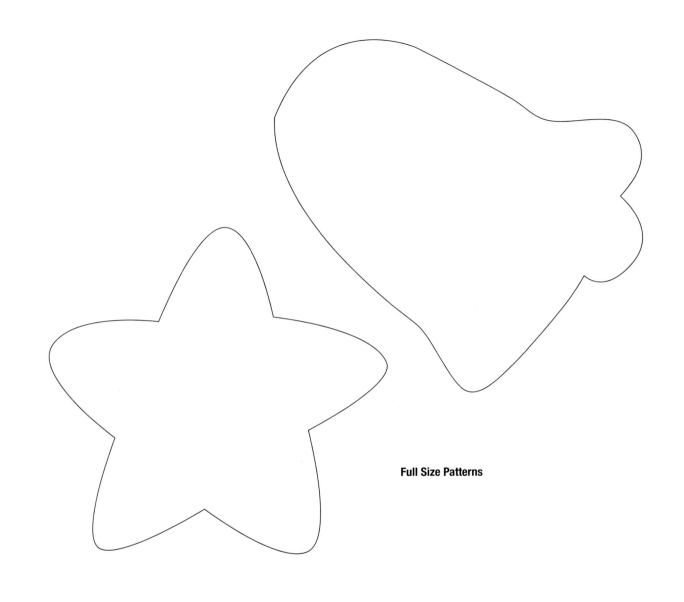

Full Size Patterns

Can't Wait 'til Christmas

Full Size Patterns

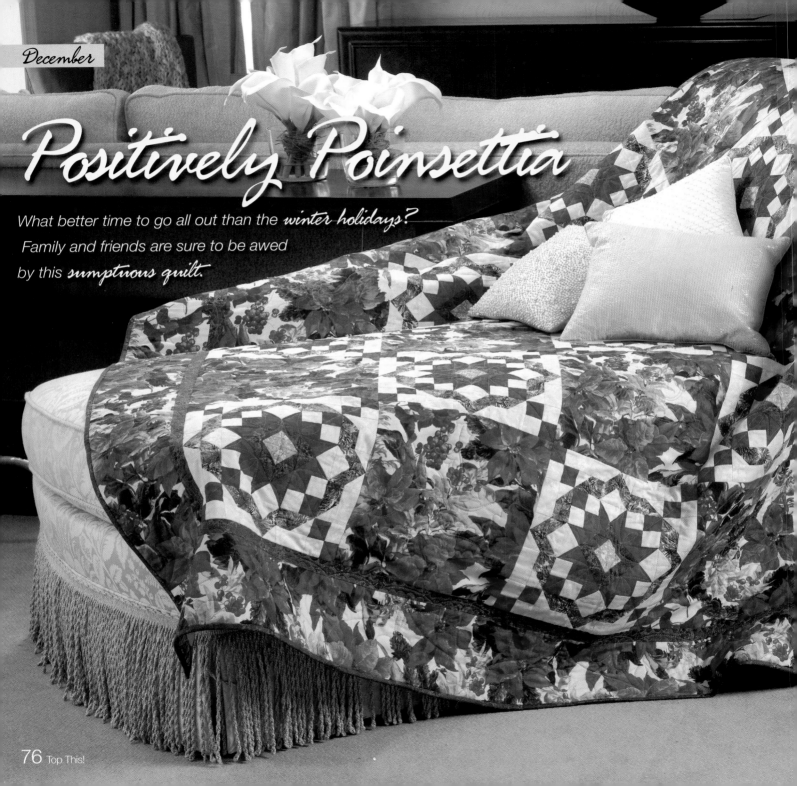

Positively Poinsettia

What better time to go all out than the *winter holidays*?
Family and friends are sure to be awed
by this *sumptuous quilt.*

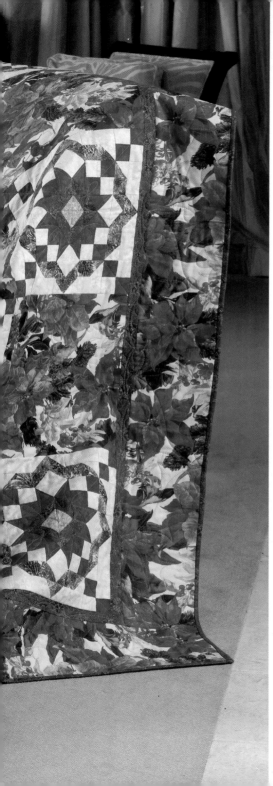

Directions

Four-Patch units

1. Stitch a 1¾" x WOF ecru strip lengthwise to a 1¾" x WOF red batik strip. Repeat to make a total of nine strip sets. Square off one end of each strip set, then crosscut two hundred and eight 1¾" wide segments. (See **Diagram 1**)

1¾"

Diagram 1

2. Sew the segments cut in step 1 together to make a total of one hundred and four, four-patch units. Set aside. (See **Diagram 2**)

make 104

Diagram 2

Half Flying Geese units

3. Following **Diagram 3**, draw a diagonal line on the wrong side of one hundred and four 1¾" ecru squares. Noting orientation of drawn line, place a square right sides together on one end of a 1¾" x 3" pinecone print rectangle. Sew on drawn line. Trim excess, leaving a ¼" seam allowance. Press open. Repeat to make fifty-two pinecone print half Flying Geese units in each orientation.

make 52

make 52

Diagram 3

4. Sew a pinecone print half Flying Geese unit made in step 3 long sides together with a 1¾" x 3" ecru rectangle. Refer to diagram for positioning. Repeat to make fifty-two units of each orientation. Set aside. (See **Diagram 4**)

 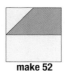

make 52 make 52

Diagram 4

Finished size 77" x 77"

Materials
- ⅓ yard gold batik
- 1 yard pinecone print
- 1¼ yards red batik
- 1⅜ yard dark green print
- 1⅞ yards ecru background
- 3 yards poinsettia print
- 83" piece of backing
- 83" piece of batting

Cutting
From the gold batik:
13: 3" squares

From the pinecone print:
156: 1¾" x 3" rectangles
104: 1¾" squares

From the red batik:
26: 3¾" squares
9: 1¾" x WOF strips

From the dark green print:
13: 3¾" squares
52: 1¾" squares
8: 1½" x WOF strips (for inner border)
8: 2¼" x WOF strips (for binding)

From the ecru background:
13: 3¾" squares
156: 1¾" x 3" rectangles
18: 1¾" x WOF strips, set 9 strips aside (for four-patch units) and recut remainder into two hundred and eight 1¾" squares

From the poinsettia print (cut in the following order):
2: 13" x WOF strips; recut into six 13" squares;
4: 6½" wide strips *lengthwise* (for outer border)
6: 13" squares (for alternate blocks)

Flying Geese units

5. Draw a diagonal line on the wrong side of one hundred and four 1¾" ecru squares. Place a square right sides together on each end of a 1¾" x 3" pinecone print piece. Stitch on the marked lines. Trim excess, leaving a ¼" seam allowance. Press open. Repeat to make fifty-two Flying Geese pinecone units. (See **Diagram 5**) Repeat with one hundred and four 1¾" pinecone print squares and fifty-two 1¾" x 3" ecru rectangles to yield fifty-two Flying Geese ecru units.

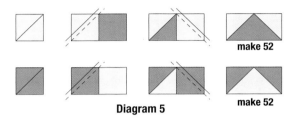

Diagram 5

6. Pair up Flying Geese units so the units are oriented in the same direction. Sew together to make a total of 52 pairs. Refer to diagram as needed. (See **Diagram 6**)

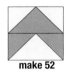

make 52

Diagram 6

Quarter-square triangle units

7. Draw a diagonal line on the wrong side of the 3¾" ecru squares. Place a square right sides together with a 3¾" red batik square. Using a scant ¼" seam allowance, stitch on each side of the drawn line. Cut apart on the line. Press seams toward the red fabric. Repeat, pairing dark green print and red batik squares. (See **Diagram 7**)

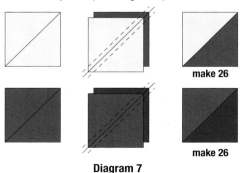

make 26

make 26

Diagram 7

8. Following **Diagram 8**, draw a diagonal line on the wrong side of the ecru/red half-square triangle units. With right sides together, nest the ecru/red half-square triangle units with the red/dark green half-square triangle units, making sure that the red is not on top of itself. Sew on both sides of the drawn line, using a scant ¼" seam allowance. Cut apart on the line. Press. Repeat to make a total of fifty-two quarter square triangle units.

Diagram 8 make 52

Square-in-a-square center units.

9. Draw a diagonal line on the wrong side of fifty-two 1¾" dark green print squares. Following **Diagram 9**, place a square right sides together on the top left corner of a 3" gold batik square. Stitch on the marked line. Trim excess, leaving a ¼" seam allowance. Press toward the outside corner. Repeat on the remaining corners. Make a total of 13 units.

make 13

Diagram 8

Assembly

10. Refer to **Block Diagram** to piece block units together. Repeat to make a total of thirteen 13" x 13" blocks.

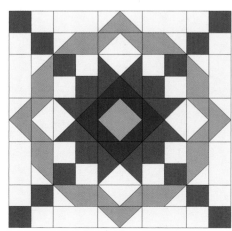

Block Diagram

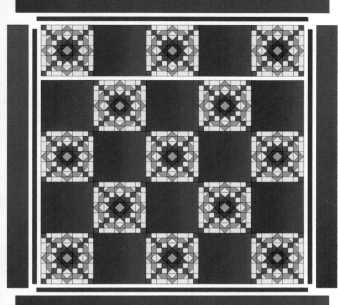

Layout Diagram

11. Sew the blocks and poinsettia print squares alternately together into five rows of five blocks each. Rows 1, 3, and 5 start and end with a pieced block, while rows 2 and 4 start and end with an alternate block. Press seams toward the alternate blocks. Sew the rows together. Press the quilt top.

12. *Inner border.* Sew the short ends of two 1½" dark green print strips together using a diagonal seam. Make four strips. Measure through the center of the quilt top for the width (should measure 63"). Cut two strips to that length and then sew to the top and bottom of the quilt center. Measure through the center of the quilt top for the length (should measure 65"). Cut the remaining two strips to that length and then sew to the sides of the quilt center. Press seams toward the inner border strips.

13. *Outer border.* Measure through the center again for the width. Cut two 6½" poinsettia strips to that length, then sew to the top and bottom of the quilt top. Press seams toward the inner border strips. In same manner, measure through the center for the length of the quilt top. Cut the remaining two 6½" wide strips to that length, then sew to the sides of the quilt top. Press seams toward the inner border strips.

finishing

14. Layer and quilt as desired.

15. Join the 2¼" dark green strips short ends together and bind as desired.

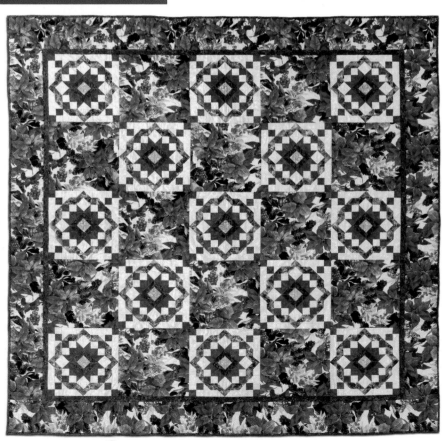

Haloed Star

Add a *touch of drama* to a small entry table
or coffee table by *dressing it up* with
this *topper* and a *holiday candle.*

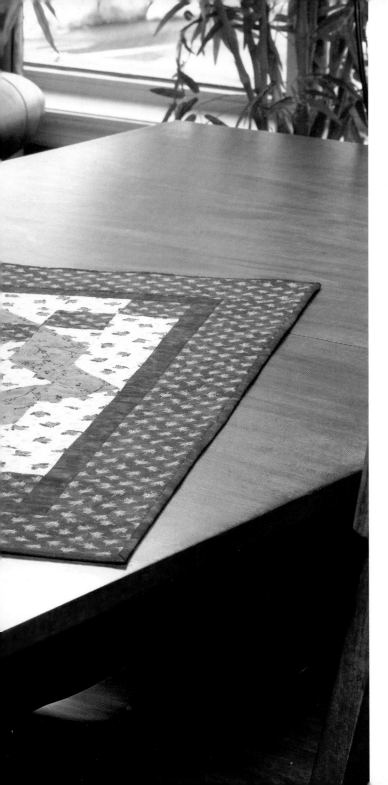

Directions

Note: The Haloed Star is a larger version of the pieced block in Positively Poinsettia. The piecing instructions are the same, except it is for one block as opposed to 13 blocks. Refer to diagrams for Positively Poinsettia as needed. (Note: Please substitute brown print for the Pincone fabric found in the Positively Poinsettia diagrams).

Four-Patch units

1. Sew a 3" wide ecru print strip lengthwise to a 3" wide red print strip. Repeat to make two strip sets. Square ends and crosscut sixteen 3" wide segments. (See **Diagram 1**)

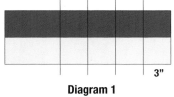

3"

Diagram 1

2. Pair the segments to make a total of eight four-patch units. Set aside.(See **Diagram 2**)

make 8

Diagram 2

Finished size 33" x 33"

Materials
Tip: Each fabric should be distinct from the others and non directional.
- ⅞ yard red print
- ⅝ yard ecru print
- ⅔ yard forest green
- ¼ yard brown print
- One 5½" square focus fabric
- 38" x 38" batting
- 38" x 38" backing

Cutting
From the red print:
1: 6¼" square
4: 3½" x WOF strips (for outer border)
2: 3" x WOF strips (for four-patch strip set)

From the ecru print:
1: 6¼" x WOF strip, recut into one 6¼" square, then cut remainder to 3" wide and subcut into sixteen 3" squares
12: 3" x 5½" rectangles
2: 3" x WOF strips (for four-patch strip set)

From the forest green:
1: 6¼" x WOF strip; recut into one 6¼" square; then cut remainder to 3" wide and subcut into four 3" squares
4: 2¼" x WOF strips (for binding)
4: 1½" x WOF strips (for inner border)

From the brown print:
12: 3" x 5½" rectangles
8: 3" squares

Half-flying geese units

3. Following **Diagram 3**, draw a diagonal line on the wrong side of eight 3" ecru print squares. Noting orientation of drawn line, place a square right sides together on one end of a 3" x 5½" brown print rectangle. Sew on drawn line. Trim excess, leaving a ¼" seam allowance. Press open. Repeat to make four brown print half Flying Geese units in each orientation (eight total brown print half Flying Geese units). Pair up the units with a 3" x 5½" ecru print rectangle as shown in **Diagram 4**.

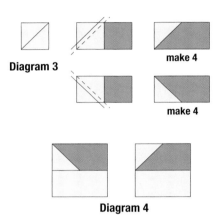

Diagram 3 make 4

make 4

Diagram 4

Flying geese units

4. *Flying Geese units.* Draw a diagonal line on the wrong side of eight 3" brown print squares. Place a square on each end of a 3" x 5½" ecru print rectangle. Trim excess, leaving a ¼" seam allowance. Press open. Repeat to make four Flying Geese ecru print Flying Geese units. (See **Diagram 5**) Repeat using four 3" x 5½" brown print rectangles and eight 3" ecru print squares to make four brown print Flying Geese units.

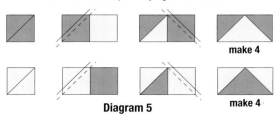

make 4

Diagram 5 make 4

5. Pair up the Flying Geese units and sew together to make four units as shown in **Diagram 6.**

Diagram 6

6. Using the 6¼" red print, ecru print, and forest green squares and following Positively Poinsettia step 7, make four quarter-square triangle units.

7. Use the 5½" focus fabric and 3" forest green squares and follow Positively Poinsettia step 9 to create the center square-in-a-square unit.

8. Following Positively Poinsettia **Block Diagram**, sew the units together to make one 25½" square block.

9. *Inner border.* Cut two 1½" wide forest green strips to measure 25" long, then sew one strip to each side of the block. Cut the remaining two 1½" wide forest green strips to measure 27½" long, then sew to the remaining sides of the block. Press seams toward the strips.

10. *Outer border.* Cut two 3½" wide red print strips to measure 27½" long. Sew these strips to opposite sides of the topper. Cut the remaining two 3½" wide red print strips to measure 33½", then sew to the other sides. Press seams toward the inner border strips.

Finishing

11. Layer and quilt as desired.

12. Bind as desired using the remaining 2¼" forest green strips.

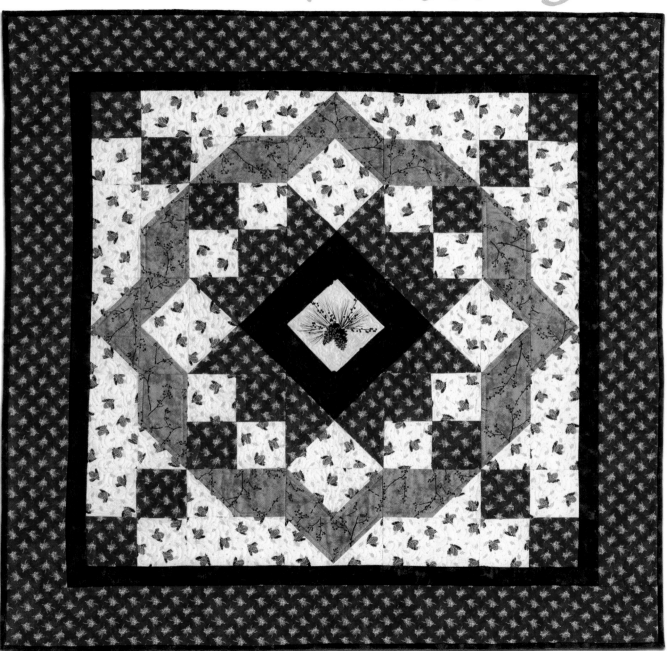

General Directions

Quilt	Approximate Size
Baby Quilt	36" x 54"
Lap Throw	54" x 72"
Twin	54" x 90"
Double	72" x 90"
Queen	90" x 108"
King	108" x 108"

Metric Conversion Chart

1/8" = 3 mm	1" = 2.5 cm	7" = 17.8 cm
1/4" = 6 mm	2" = 5.1 cm	8" = 20.3 cm
1/2" = 1.3 cm	3" = 7.6 cm	9" = 22.9 cm
3/4" = 1.9 cm	4" = 10.2 cm	10" = 25.4 cm
7/8" = 2.2 cm	5" = 12.7 cm	11" = 27.9 mm
	6" = 15.2 cm	12" = 30.5 mm

1/8 yd. = 0.11 m	1/2 yd. = 0.46 m
1/4 yd. = 0.23 m	3/4 yd. = 0.69 m
1/3 yd. = 0.3 m	1 yd. = 0.91 m

Approximate Conversion To Metric Formula

When you know:		Multiply by:		To find:
inches (")	x	25	=	millimeters (mm)
inches (")	x	2.5	=	centimeters (cm)
inches (")	x	0.025	=	meters (m)
feet (' or ft.)	x	30	=	centimeters (cm)
feet (' or ft.)	x	0.3	=	meters (m)
yards (yd.)	x	90	=	centimeters (cm)
yards (yd.)	x	0.9	=	meters (m)

Before beginning, read the directions for the chosen pattern in their entirety. Wash all fabric in the manner in which you intend to wash the finished quilt. This preshrinks the fabric and ensures that it is colorfast. Dry fabric and press to remove wrinkles.

Most fabrics are sold as 44" wide from selvedge to selvedge, but many vary slightly in width. Fabric width may also change after the fabric is washed. The materials lists and cutting directions in this book are based on a width of at least 42" of useable fabric after washing and after the selvedges have been trimmed.

Backing fabric and batting dimensions listed are for hand quilting or for quilting on a home sewing machine. Professional quilters using a longarm machine may require a larger backing and batting size. If you intend to have someone else quilt your project, consult them regarding backing and backing size. Cut backing fabric and sew pieces together as necessary to achieve the desired size.

Patterns

The patterns provided for pieced quilts are full size with an included 1/4" seam allowance. The solid line is the cutting line, and the dashed line is the stitching line. A seam allowance is not included on appliqué patterns. Trace all, including any grainline arrows, onto template material.

Marking Fabric Pieces

Test marking pens and pencils for removability before marking pieces for your quilt. If the pattern piece includes a grainline arrow, align the arrow with the fabric grain. Use your marker to trace around the template on the right side of the fabric. Then cut the pieces out.

If you wish to mark the sewing line, use a quilter's 1/4" ruler to measure and mark the seam allowance on the wrong side of the fabric. Mark the pieces needed to complete one block, cut them out, and stitch them together before cutting pieces for the entire quilt.

Trace appliqué patterns lightly on the right side of the fabric or place the templates face down on the wrong side of the fabric. Add the seam allowance specified in the pattern when cutting the fabric pieces out.

Piecing

Set up your machine to sew 12 stitches per inch. If you have not marked the stitching line on fabric pieces, be careful to align fabric edges with the marks on the throat plate of your machine, as necessary, to achieve an accurate 1/4" seam allowance. You can also make a stitching guide in the following way: Place a ruler under the presser foot of the sewing machine aligning the 1/4" marked line on the ruler with the needle. Align a piece of masking tape or a rectangle cut from a moleskin footpad along the right edge of the ruler. Remove the ruler, and place fabric edges against the stitching guide as you sew. Stitch fabric pieces from edge to edge unless directed otherwise in the pattern.

Sew fabric pieces together in the order specified in the pattern. Wherever possible, press seam allowances toward the darkest fabric. When butting seams, press seam allowances in opposing directions.

Fusible Appliqué

This method allows you to complete appliqué very quickly. Follow the directions on the fusible product to prepare and attach appliqué pieces. For most fusible products, it is necessary to flip asymmetrical templates right side down before tracing them on the paper side of the fusible web. Finish the edges of fused appliqué pieces by hand using a blanket stitch or by machine using either a blanket or satin stitch.

Foundation Piecing

Foundation patterns are full size and do not include seam allowances. Trace the foundation patterns onto foundation paper making the number of foundations specified in the quilt pattern. You will piece each foundation in numerical order, placing fabric pieces on the unmarked side of the foundation, then turning the foundation over and stitching on the marked lines. Cut each fabric piece large enough to extend at least ¼" beyond the stitching lines of the section it will cover after it is stitched.

Begin by placing the first fabric piece right side up over section 1 on the unmarked side of the foundation. Hold the foundation up to a light source to better see the marked lines. Place the second piece of fabric right side down over the first piece. Pin fabrics in place if desired. Turn the foundation over and stitch on the line between section 1 and section 2 extending the stitching by two or three stitches on each end of the marked line. Fold the paper foundation along the stitched line so that the seam allowance of the stitched pieces extends beyond the paper. Align the ¼" line of a ruler along the stitches and trim the seam allowance to ¼". Open up the paper, flip the fabric pieces open, and press the unit. Continue adding fabric pieces in the same manner as the second fabric piece until the entire foundation is covered. Trim fabrics ¼" beyond the edges of the foundation. Stitch foundations together as described in the quilt pattern using the paper foundations as a stitching guide. Gently remove foundation paper when instructed to do so in the quilt pattern.

Mitering Border Corners

Miter Diagram

Fold a border strip in half crosswise to determine the center. Match the center of the border to the center of the quilt, and pin the border to the quilt. Stitch the border to the quilt, beginning and ending exactly ¼" from the quilt edges. Backstitch to secure the stitching at each end. Attach all four borders in the same manner.

Place the quilt right side down on a flat surface, and place one border over the adjacent border as shown. Using a ruler, draw a line at a 45° angle from the inner edge of the uppermost border to the outside edge. Reverse the positions of the borders and repeat to mark a second line. Mark all borders in the same manner.

Pin each set of adjacent borders right sides together along the marked lines. Stitch on the lines from the inner to the outer edge. Backstitch at each edge to secure the seam. Turn the quilt over and check each mitered seam. Trim the seam allowances to ¼".

Marking the Quilt Top

Press the quilt top. Test all markers for removability before using them on your quilt. If using a paper design, place it under the quilt top, and trace the design. Use a light source if necessary. If using a stencil, place it on top of the quilt top, and trace the open areas. Use a ruler to mark straight lines such as grids or diagonals that cross fabric pieces.

Masking tape can be used as an alternative to marking straight lines. Place the tape on the quilt where desired and stitch along the edge. Contact paper can be cut into strips and used in the same manner. It can also be cut into other quilting shapes or stencils. Remove tape and contact paper from the quilt top daily to avoid leaving a sticky residue on the quilt.

Basting

The day before you intend to baste the quilt, open up the batting and place it on a flat surface (a bed or carpeted area is ideal). The next day, place the pressed backing fabric wrong side up on a flat, solid surface. Secure the backing in place with masking tape. Smooth the batting on top of the backing. Center the quilt top right side up on the batting.

Use a needle and thread in a color that contrasts with the quilt. Baste with large stitches keeping all knots on top of the quilt. Begin in the quilt center and baste first horizontally, then vertically, and finally diagonally to the edge of the quilt top. Also baste at least two rectangles as shown.

To prepare your quilt for quilting on your home sewing machine: Use soluble thread to baste the quilt, or baste using safety pins.

Quilting

Many fine books are available on both hand and machine quilting. Basic hand quilting is described here.

Use quilting thread and a short, strong needle. Place a thimble on the middle finger of your preferred hand. Always begin quilting in the center of the quilt and work your way toward the quilt edge. Make a small knot at the end of the thread, and insert the threaded needle into the quilt top and batting only near where you wish your first quilting stitch to appear. Exit the needle at the beginning of where you want your first visible stitch to be, and gently pop the knot between the fabric fibers into the quilt top.

Begin quilting as follows: Keeping your preferred hand above the quilt and your other hand below it, use your thimbled finger to push the needle straight down through all layers of the quilt. When you feel the tip of the needle with the index or middle finger of the hand that is below the quilt, use the thumb of your preferred hand to depress the quilt top, and redirect the needle back through the quilt layers to the top of the quilt. Continue in this manner using a rocking motion with your preferred hand. When the thread becomes short, make a small knot at the surface of the quilt top. Then take a stitch and pop the knot into the quilt. Cut the thread where it exits the quilt top. Do not remove basting stitches until quilting is complete.

Binding Strips

Quilts with straight edges can be bound with binding strips cut with the grain of the fabric. Cut binding strips the width specified in the quilt pattern, and sew them together with diagonal seams in the following way: Place two binding strips right sides together and perpendicular to each other, aligning the ends as shown. Mark a line on the top strip, from the upper left edge of the bottom strip to the lower right edge of the top strip, and stitch on the marked line. Trim the seam allowance ¼" beyond the stitching, open up the strips, and press the seam allowance open. When all binding strips have been stitched together, fold the strip in half lengthwise (wrong side in) and press.

Bias Bindings

Quilts with curved edges must be bound with binding strips cut on the bias. Cut bias strips by aligning the 45° line on a rotary cutting ruler with the bottom edge of the fabric and cutting along the ruler's edge.

Attaching the Binding

Leaving at least 6" of the binding strip free and beginning several inches away from a corner of the quilt top, align the raw edges of the binding with the edge of the quilt top. Using a standard ¼" seam allowance, stitch the binding to the quilt, stopping and backstitching exactly ¼" from the corner of the quilt top.

Remove the quilt from the sewing machine, turn the quilt so the stitched portion of the binding is away from you, and fold the binding away from the quilt, forming a 45° angle on the binding. *Hint: When the angle is correct, the unstitched binding strip will be aligned with the next edge of the quilt top.*

Maintaining the angled corner fold, fold the loose binding strip back down, aligning this fold with the stitched edge of the quilt top and the raw edge of the binding with the adjacent quilt top edge. Stitch the binding to the quilt beginning at the fold, backstitching to secure the seam.

Continue attaching the binding in the same manner until you are 6" from the first stitching. Then, fold both loose ends of the binding strip back upon themselves so that the folds meet in the center of the unstitched section of the binding, and crease the folds.

Measure the width of the folded binding strip. Cut both ends of the binding strip that measurement beyond the creased folds. (For example: If the quilt pattern instructed you to cut the binding strips 2½" wide, the folded binding strip would measure 1¼". In this case, you would cut both ends of the binding strip 1¼" beyond the creased folds.)

Open up both ends of the binding strip and place them right sides together and perpendicular to each other as shown. Mark a line on the top strip from the upper left corner of the top strip to the lower right corner of the bottom strip. Pin the strips together and stitch on the marked line.

Refold the binding strip and place it against the quilt top to test the length. Open the binding strip back up, trim the seam allowance ¼" beyond the stitching, and finger press the seam allowance open. Refold the binding strip, align the raw edges with the edge of the quilt top, and finish stitching it to the quilt.

Trim the batting and backing ⅜" beyond the binding stitching. Fold the binding to the back of the quilt, and blind stitch it to the backing fabric covering the machine stitching. Keep your stitches small and close together. When you reach a corner, stitch the mitered binding closed on the back side of the quilt, and pass the needle through the quilt to the right side. Stitch the mitered binding closed on the front side of the quilt, and pass the needle back through the quilt to the back side. Continue stitching the folded edge of the binding to the back of the quilt.

Finishing Your Quilt

Remove all quilt markings. Make a label that includes your name, the city where you live, the date the quilt was completed, and anything else you would like future owners of the quilt to know. Permanent fabric pens make this task easy and allow you to make the label as decorative as desired. Stitch the label to the back of the quilt.

Nona Davis

One of my earliest memories is of sitting on the floor of my grand-mother's kitchen playing with the scraps she gave me as she pieced dresses and aprons. I have enjoyed a variety of needlework techniques throughout my life but felt I found my niche when I took my first quilting class in the late 1980's. Once the kids were nearly grown, my husband Gary and I started Mrs. Sew-n-Sew's Quilt Shop in the small town of St. Maries, Idaho in spring of 2000. Whether teaching beginning quilt classes, mystery classes or a specific technique, I encourage students to express their own creativity through fabric choices or design placement. Being surrounded by beautiful fabric on a daily basis is inspiring. I initially began designing patterns to fit the needs of individual customers. I gradually developed a habit of sitting with a graph pad handy every evening, doodling out designs. A talented designer in his own right, Gary enjoys designing quilts with a wildlife motif. We are partners in our design company, Another Sew-n-Sew Designs. Gary drew the bear for the June projects.

From early spring through fall, we travel around the northwest and vendor at numerous quilt shows . To see available kits and patterns, visit our website: **www.mrs-sewnsew.com.**

We live in the country in northern Idaho and have five grown children and eleven grandchildren, three yaks and an ornery cat.